IMAGES of America
INDIANA'S COVERED BRIDGES

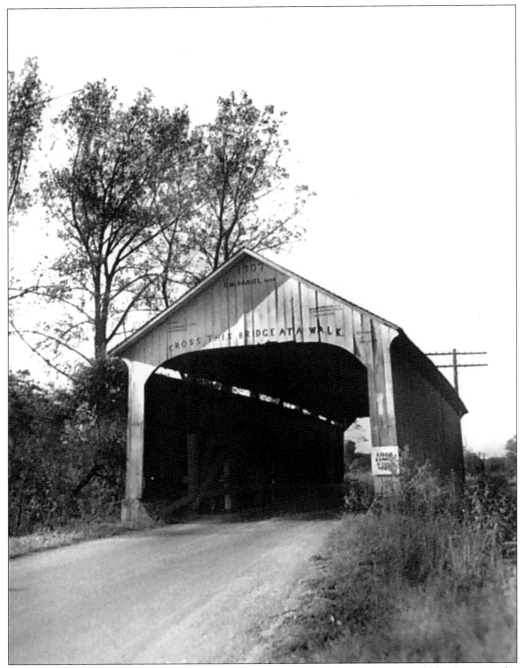

PARKE COUNTY. This is a striking view of the south end of the Catlin covered bridge in Parke County as it looked in the 1940s on its original site. The structure was built in 1907, and was eventually relocated to the Parke County Golf Course. Across its portal is a familiar message for travelers at the time, "cross this bridge at a walk." Today the existence of the Catlin and dozens of other covered bridges within its western Indiana boundaries give rise to Parke County's claim to being the covered bridge capital of the world.

IMAGES of America

INDIANA'S COVERED BRIDGES

Robert Reed

Copyright © 2004 by Robert Reed
ISBN 978-0-7385-3335-3

Published by Arcadia Publishing
Charleston, South Carolina

Printed in the United States of America

Library of Congress Catalog Card Number: 2004108960

For all general information contact Arcadia Publishing at:
Telephone 843-853-2070
Fax 843-853-0044
E-mail sales@arcadiapublishing.com
For customer service and orders:
Toll-Free 1-888-313-2665

Visit us on the Internet at www.arcadiapublishing.com

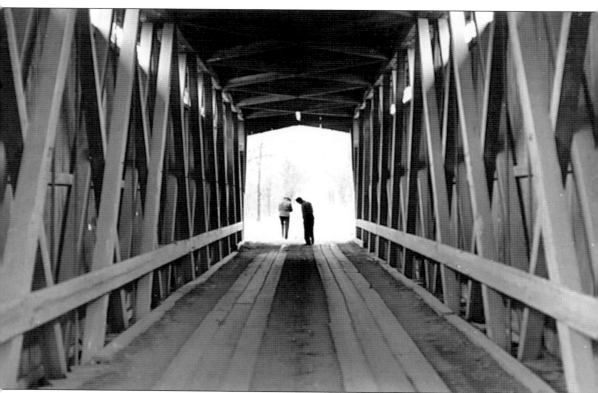

INDIANA INTERIOR. The remarkable interior structure of one of Indiana's covered bridges as it appeared during the 1940s is pictured here. The wooden timbers would hold up to the ravages reasonably well, even without being covered. However their complicated joints were often held with wood pins, and were vulnerable to the effects of water. Such would deteriorate rapidly if not protected.

Contents

Acknowledgments		6
Introduction		7
1.	Covered Bridge Counties: Adams to Wells	9
2.	Covered Bridge Celebrations	121
3.	Indiana Covered Bridge Festivals	127
Index		128

Acknowledgments

My deepest appreciation to my wife and life partner Claudette Swengel Reed, for her love and support in all aspects of my life.

Special appreciation to Jan Harvey of the National Road Antiques Mall in Cambridge City, Indiana for generous access to a wealth of original resource materials regarding Indiana's covered bridges. A number of vintage photographs were also provided from the extensive collection of Robert Williams of Fountain City.

Research has included a vast number of reference works including the Directory of Covered Bridges of Indiana by Robert Yule and Richard Smith; Indiana Covered Bridges Thru the Years by George Gould; Covered Bridges on the Byways of Indiana by Bryan Ketcham; The Covered Bridges of Indiana by Max Harvey; Greetings From Indiana by Robert Reed; Covered Bridges of the Middle West by Richard Sanders Allen; Central Indiana's Interurban by Robert Reed; the "Indiana History Bulletin of the Indiana Historical Bureau;" and photographic works of George Aten and Robert Finnegan.

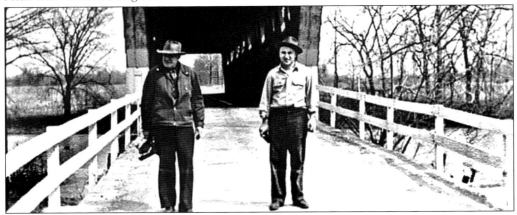

Indiana Photographers. Two pioneering Indiana photographers, George Aten and Robert Finnegan, stand before one of Indiana's covered bridges shortly before the middle of the 20th century. The two traveled the highways and byways of the state recording covered bridges in their original state before many such bridges were abandoned.

INTRODUCTION

First there were many. Now there are few.

Once there were hundreds of covered bridges in Indiana. They were so numerous and so spread throughout the state's 92 counties that in fact no one knew the exact count. Now there are less than 100 covered bridges remaining in the Hoosier state.

Solid-timber covered bridges were constructed in the United States extensively in the 19th century and to a much lesser degree early in the 20th century. Their main purpose was to protect the wooden base of the bridge in general and to protect the inter-workings of bridge frames in particular. The timber itself actually held up pretty well over the years, but the so-called joints of the bridges were much more complicated and much more vulnerable to the weather. Often they were held together with a series of wooden pins which especially needed protection from the elements.

Such covered bridges were popular in an era when both lumber and labor were plentiful and relatively inexpensive. In the early days, 1,000 feet of lumber sold for $6 and husky young men were willing to toil from dawn to dusk for around $1 a day. Later, both of those costs increased, but even late in the 19th century a very nice covered bridge could be constructed in Indiana for little more than $2,000.

Indiana covered bridges first appeared in the Hoosier state during the 1830s as travelers sought a better route across the center of the state on the National Road (now U.S. 40). Ironically the very first covered bridge, a relatively short 49-foot span over Symons Creek in Henry County, was completed near Straughn, just a few miles from Knightstown where this book was completed.

That first small covered bridge was completed in the summer of 1834, and it was soon overshadowed by the construction later that year of a major covered bridge in Richmond and a long-delayed project in Indianapolis. All three were efforts to enhance travel on the National Road.

Through the years, hundreds of covered bridges were added to the Indiana landscape. Although the early examples spanned waterways on the National Trail route, most of Indiana's remaining covered bridges were typically county projects designed to help farmers and others cross streams with their goods and products. Before, much travel involved 'fording' a creek, which meant attempting to cross where the water was most shallow. At certain times of the year, swollen streams made it impossible to even find a shallow enough spot to safely cross. Covered bridges, safe and sturdy, were looked upon as wondrous in the 19th century.

In the eastern United States, early covered bridges were often financed with tolls, charging so much for livestock and usually a lesser sum for horse and rider or horse and buggy. By the time covered bridges became practical in Indiana the charging of tolls was generally abandoned in favor of tax assessment and contributions. Residents were sometimes so grateful for a future bridge that they would contribute a goodly portion of the structure's cost directly to the county commissioners.

As popular as covered bridges eventually became in Indiana, most readers would probably not immediately think of the Hoosier state as a bastion of bridges. But it was.

It is entirely logical to think of the New England states as the prime source of covered bridges; certainly they were. The covered bridge concept started there and prospered there, but oddly it did not *endure* there as it did elsewhere.

By the late 1930s, covered bridges had pretty much disappeared in once-favored places like Maine, Massachusetts, Connecticut, and New Hampshire. The hundreds of remaining bridges at the time in the Hoosier state put Indiana third in the nation, behind only Pennsylvania and Ohio, in the number of covered bridges still standing.

In Indiana, just as in New England, times changed. The demands of modern traffic more or less doomed the covered bridge. In this state, just as eastward, many bridges were simply abandoned and allowed to deteriorate; others were replaced with steel or concrete structures. But the major difference was some serious effort in Indiana to preserve and protect these historical bridges.

As early as 1930, the statewide Indiana Covered Bridge Committee was formed in an organized campaign to save as many covered bridges as possible. Even as late as 1938, their leader, R.B. Yule was optimistic.

"The committee hopes to have several good examples of covered bridge construction in parks or on secondary roads preserved for the use and interest of several generations to come," Yule wrote in the October 1938 issue of Highway magazine.

Yule, who was also an engineer for the Indiana State Highway Commission, concluded, "Like most engineer works where motion is involved, careful maintenance will keep for us indefinitely these useful relics of a past generation."

By the 1940s, a few pioneering photographers were at work too, preserving existing covered bridges in Indiana as best they could by capturing their rustic images for others to see. Among the most admirable of these photographers were George Aten and Robert Finnegan who tirelessly traveled the byways and highways in search of the remaining structures, carefully documenting their details.

In those days there were more than 400 covered bridges in the state. Half a century later, despite the efforts of Yule, Aten, Finnegan, and many others, the count of Hoosier bridges still standing (although some had been relocated) had dropped to a fraction of that number.

Many of the vintage black and white photographs of the era of Aten and Finnegan have not previously been published in book form. Yet they are an important and legendary part of Indiana's covered bridge history.

One

COVERED BRIDGE COUNTIES
Adams to Wells

Once there was an abundance of covered bridges constructed on the major and the not-so-major roadways of Indiana during the 19th century and into the first few decades of the 20th century. Unfortunately, after a time, they began disappearing almost as rapidly as they were built. In some cases they were simply abandoned in favor of replacement bridges. At other times they were destroyed by floods, fire, or other circumstances and never replaced. In a few cases, public officials and dedicated supporters displayed distinguished foresight in actually relocating covered bridges to public locations where they could be admired and enjoyed by future generations.

While there are many lists of where covered bridges once stood in Indiana, there remains to be one compiled that is comprehensive. The covered bridge was almost always the responsibility of the individual county whose century-old records were often out of date and lacking detail.

As a further complication, particular bridges might have had a variety of names. When first constructed, the county commissioners may have named it after a contributing landowner. Later, the same bridge might have assumed the name of the nearest town or mill site. And still later, it may have been given still another location-related name, which might have been significant to local residents but rather vague as a tool for record-keeping.

While many covered bridges have been restored to their past glory, i.e. Parke County, most are quite literally and figuratively history. The following are Indiana counties where covered bridges have survived, at least in vintage photographs: Adams, Allen, Brown, Carroll, Clay, Decatur, DeKalb, Delaware, Fayette, Fountain, Grant, Hamilton, Huntington, Jackson, Jennings, Knox, Lake, LaPorte, Lawrence, Marion, Monroe, Montgomery, Own, Parke, Putnam, Randolph, Rush, Union, Vermillion, Vigo, Wabash, Warren, Warrick, Wayne, and Wells.

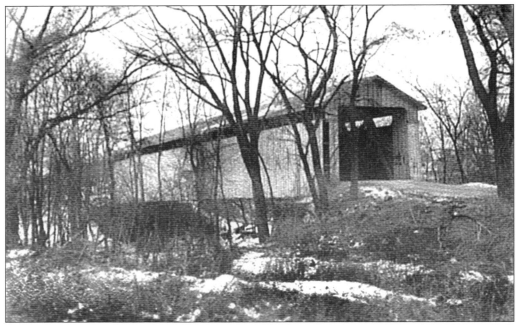

ADAMS COUNTY. This is a view of the covered bridge at Pleasant Mills in Adams County. It was constructed in 1881 and crossed a portion of the St. Mary's River. A second Adams County covered bridge was still operational when this bridge was photographed by R.C. Finnegan in the 1940s.

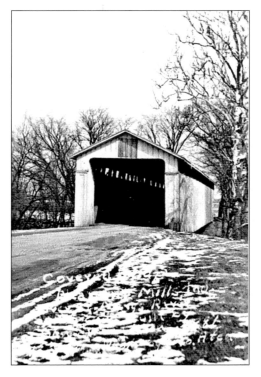

ADAMS COUNTY. Pleasant Mills covered bridge rises from the winter landscape of Adams County. The late-19th century bridge was still very much in use during the 1940s when photographed by George Aten. The Pleasant Mills covered bridge and a second Adams County covered bridge two miles northeast of Geneva were both listed in the Directory of Covered Bridges of Indiana published in 1940

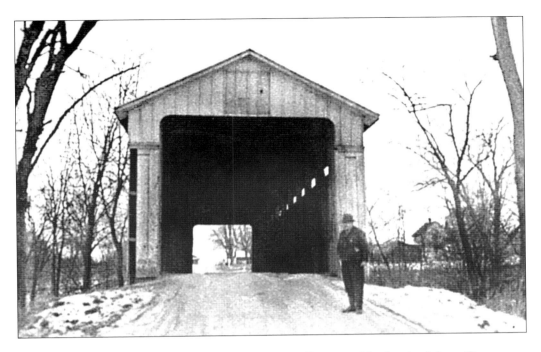

ADAMS COUNTY. Varying views of the Pleasant Mills covered bridge in Adams County are seen here, as photographed by R.C. Finnegan (above) and George Aten (below). Legend has it that the width and height of covered bridges of this type were determined by what amounted to a large load of hay in the 19th century. The bridge was built to accommodate a "load of hay" pulled through its interior by a farm wagon. Portals were arched to avoid accumulation of water and to further allow unobstructed passage of the tall hay stacks.

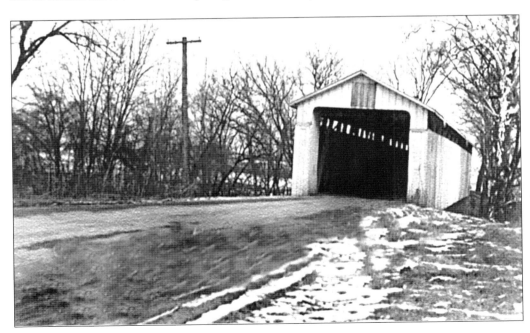

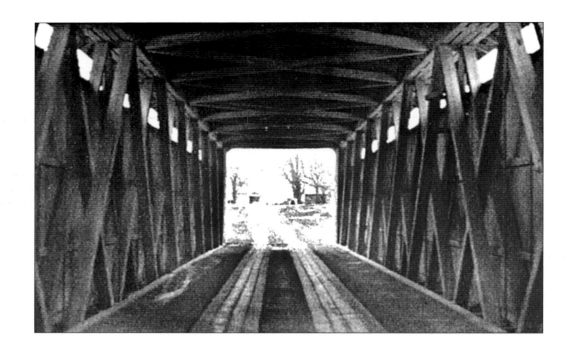

ADAMS COUNTY. When these photographs by George Aten (above) and Robert Finnegan (below) were taken, this Pleasant Mills structure was the most prominent of Adams County's covered bridges. The 1940 state directory mentioned a second such bridge near Geneva. Omitted, however, were earlier covered bridges at Ceylon and Price; both 'bridged' the Wabash River earlier in the century.

ADAMS COUNTY. In 1948, documents of the American Covered Bridge Society confirmed that the covered bridge at Pleasant Mills had been condemned in the spring of that year. According to the group, this meant "school buses are not allowed to cross the bridge. Road 101 is still routed on the bridge with load limitations."

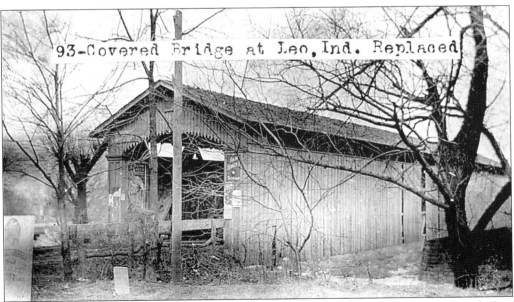

ALLEN COUNTY. This covered bridge at Leo had been replaced in Allen County long before statewide efforts starting in the 1930s to at least document, if not fully preserve, Indiana's covered bridges. This bridge spanned the St. Joseph River and bore the same name as the community it served.

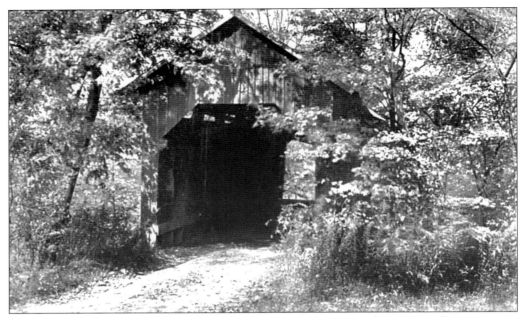

BROWN COUNTY. A rustic covered bridge over Bean Blossom Creek in Brown County is seen here. This bridge, built in 1880, was still standing during a study by the Indiana Highway Survey Commission in 1937. For all of its beauty however, it never achieved the fame of Brown County's other covered bridge in nearby Nashville. The Bean Blossom Bridge was by-passed and collapsed from neglect in the 1960s.

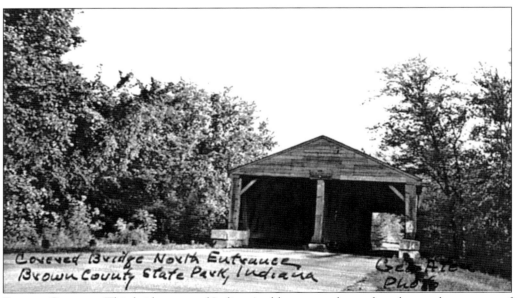

BROWN COUNTY. This bridge, one of Indiana's oldest, was relocated to the north entrance of Brown County State Park in Nashville during the Great Depression of the 1930s. The so-called Ramp Creek Bridge serves as a crossing over the small stream of Sand Creek.

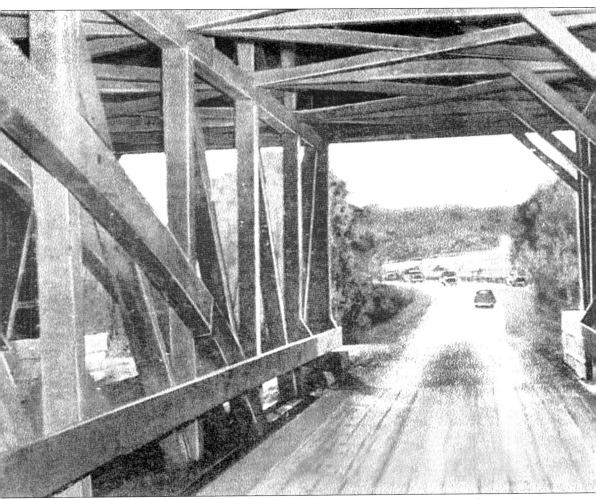

BROWN COUNTY. This is a unique inside-looking-out view of the covered bridge in Brown County State Park in Nashville, the Ramp Creek Bridge. This postcard view was taken in the 1940s, at the time the Bean Blossom Bridge was also standing in Brown County. The Ramp Creek Bridge was originally built in 1838 near Fincastle by bridge architect Aaron Wolf. After nearly a century of service there, it was moved in 1932 some 125 miles to the state park. In 1970, the American Society of Covered Bridges declared it to be the state's oldest bridge still retaining its original shape and dimensions. The bridge was one of the few surviving double-barrel or two-lane covered bridges in the state of Indiana.

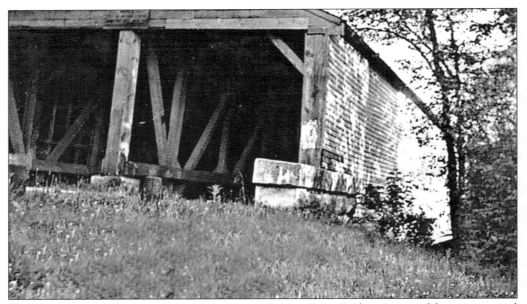

BROWN COUNTY. This covered bridge at Brown County State Park was rescued from its original location in another remote part of the state of Indiana. The entire bridge is some 60 feet long and incorporates the Burr arch. It was completely restored when relocated from Putnam County to the state park in the 1930s.

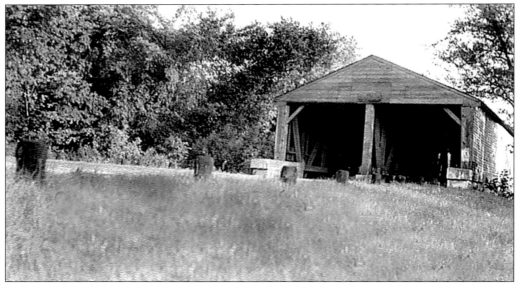

BROWN COUNTY. The Burr truss design of this Brown County covered bridge was originally accredited to Theodore Burr of Massachusetts. The combined arch and truss, or enclosed structure of timbers, was a very popular method of bridge building in the 19th century.

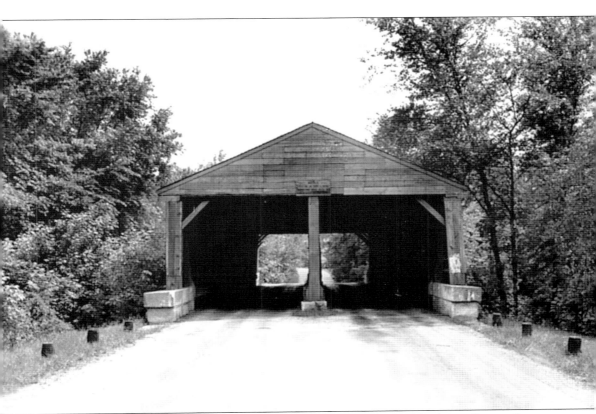

BROWN COUNTY. This is a good view of the double-barrel covered bridge at Brown County State Park as it looked during the 1940s. The term "double-barrel" applied to a covered bridge with two lanes instead of the much more common single lane. The double-barrel was put into use on roadways perceived to bear heavier traffic. Typically the design called for heavier truss construction than single-lane bridges. Initially, covered bridges on the National Road in Indiana, including those in Richmond and Indianapolis, had the double-barrel design. Ironically most of the double-barrel bridges were more quickly replaced due to the demands of even heavier traffic. Decades ago the national newsletter, Covered Bridge Timber, noted that double-barrel bridges were usually replaced because of the need for wider traffic lanes and "not from any failure in their construction."

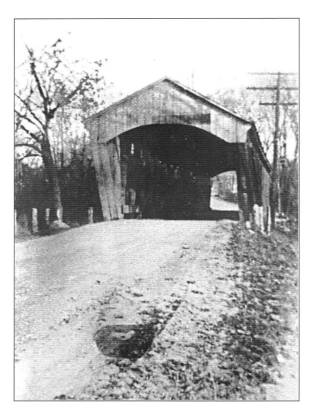

CARROLL COUNTY. This Cutler covered bridge spanned Wildcat Creek in Carroll County; it was one of four listed in the 1940s edition of the Directory of Covered Bridges of Indiana. Built in 1872, it was one of two built in the same year in the immediate vicinity of Cutler.

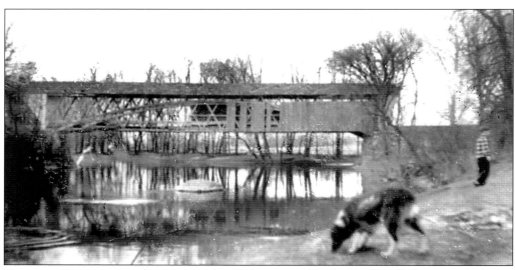

CARROLL COUNTY. Another view of the Cutler covered bridge in Carroll County, which was constructed in the latter part of the 19th century and has long since disappeared. The bridge extended 130 feet as it crossed the north fork of Wildcat Creek.

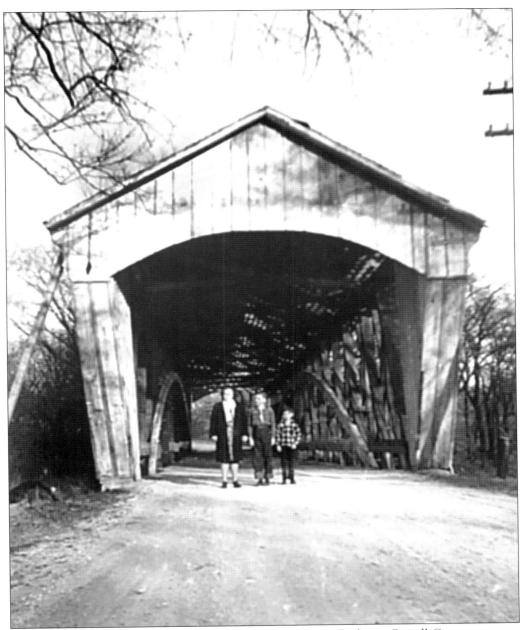

CARROLL COUNTY. This distinguished covered bridge near Cutler in Carroll County was one of four singled out in the 1930s by the Indiana State Highway Commission. They listed two near Cutler, a third just east of Owasco, and a fourth just south of Pyrmont. Each of the four spanned a different portion of the Wildcat Creek. The Cutler area bridges were of the Howe truss-type design, and the one pictured above was further mounted on specially prepared cast iron abutments. The abutments had been patented in 1870 by A. Wheelock of Fort Wayne, Indiana. Truss systems and other more elaborate additions were often patented, and became very profitable for their inventors during the 19th century. The inventors, in turn, licensed the use of their systems based on the length of an individual bridge.

CARROLL COUNTY. Depending on which historical list is consulted, this bridge was either "just east" of Owasco or northeast of Owasco in Carroll County. Generally it was called the Lancaster covered bridge; it was 133 feet in length.

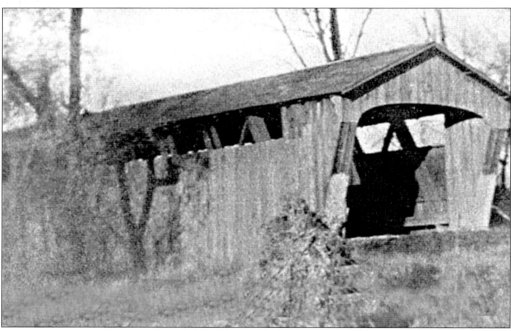

CARROLL COUNTY. Owasco covered bridge in Carroll County is shown here as it appeared around 1947, when it was photographed by Robert Finnegan. Eventually the bridge, built in the 1870s, was relocated to Wild Cat Creek as a landmark. The original site is located near what is now known as County Road 500 West.

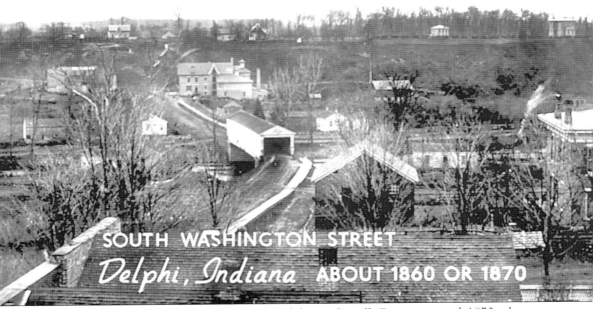

CARROLL COUNTY. A bird's eye view of Delphi in Carroll County around 1870s shows a covered bridge in the center of the robust community. This Washington Street covered bridge crossed Deer Creek during the latter part of the 19th century. However the structure had long since disappeared when the statewide effort for covered bridge preservation and restoration began in the 1930s. Decades later, Everett Wilson wrote in the book, *Vanishing Americana*, "although determined efforts are made by some tradition-conscious communities to preserve those picturesque structures, others seemingly care little about them. The result is that our covered bridges are disappearing one by one, victims of fire, flood, rot, and sheer neglect. And with each goes our precious heritage."

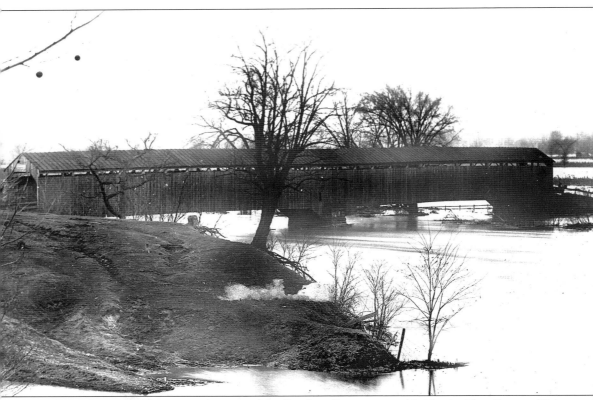

CLAY COUNTY. This is a stark scene of the Bowling Green covered bridge in Clay County. This remarkable bridge was erected in 1854 and served the area for generations before finally falling into disrepair. In 1935, following completion of the "new highway bridge" the Clay county commissioners ordered the county engineer to dismantle the bridge. A Bowling Green resident reportedly contacted the Indiana Historical Society. Ultimately the group's Covered Timber Bridge chairman, R.B. Yule wrote a letter to the commissioners stressing the bridge's history and the part it played for generations of travelers. Meanwhile farmers kept using the span, tearing down the boards which had been used to block the bridge's portals. County officials next acted to thwart passage by removing flooring from the bridge. At 10:35 a.m. on June 1, 1945 the mighty bridge collapsed into the Eel River. A few months later the remains the bridge were sold to the highest bidder.

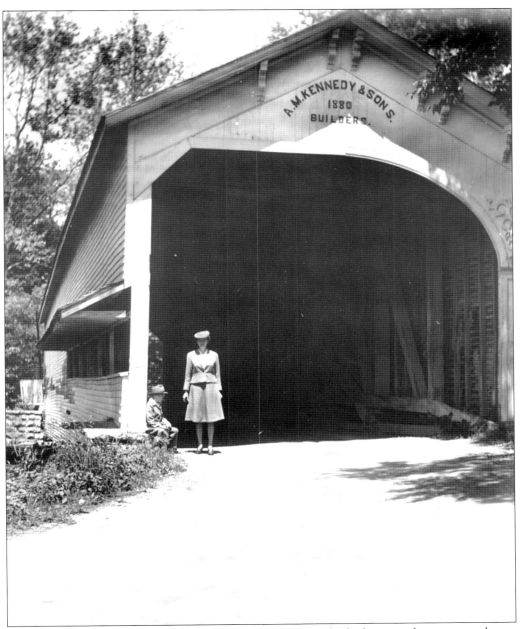

DECATUR COUNTY. Visitors pose on the covered bridge, which then stood just one and one-half miles southeast of Westport in Decatur County. This vintage scene dates to the 1940s. The bridge was erected in 1880 by Archibald M. Kennedy and Sons over Sand Creek. Kennedy was one of Indiana's most prolific builders of covered bridges. Kennedy began building bridges in 1870, and over the years his operation eventually included sons Emmett and Charles. Combined, the Kennedy firm built some 60 bridges in Indiana and neighboring Ohio. This structure was the only covered bridge listed in Decatur County in the 1940 edition of the Directory of Covered Bridges of Indiana. Historically, this structure was referred to as the Westport Bridge.

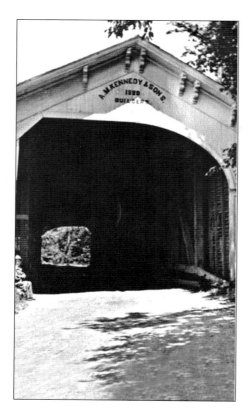

DECATUR COUNTY. This close-up view shows the portal of the Westport covered bridge in Decatur County. During the late 19th century it was typical to list the name of the bridge-builder at its entrance. In this case it was A.M. Kennedy and Sons. This photograph was taken when the bridge was about 60 years old.

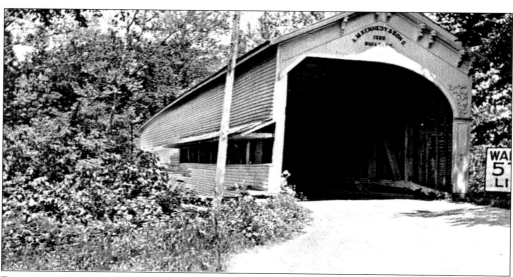

DECATUR COUNTY. This view of the Westport covered bridge in Decatur County shows how it looked in the 1940s. The bridge spanned Sand Creek in Westport, and was 131 feet in length. It was of the Burr arch design which was a popular standard for covered bridges in Indiana during the latter part of the 19th century. The builder, A.M. Kennedy and Sons, continued to provide covered bridges well into the 20th century in the Hoosier state.

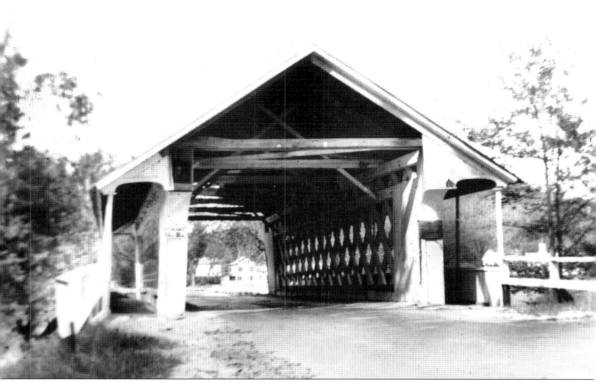

DELAWARE COUNTY. Pictured here is an impressive covered bridge, which stood at Muncie in Delaware County. The structure crossed the west fork of White River and even included covered walkways for pedestrians. This bridge was constructed in 1898 and is shown here as it appeared about 25 years later. Of the two Muncie-area covered bridges, one was located at Walnut Street while another was located on Wheeling Pike. This particular bridge had disappeared by the time the Covered Timber Bridge Committee of the Indiana Historical Society was formed in the 1930s. No Delaware County covered bridges made the official Directory of Covered Bridges of Indiana compiled some years later.

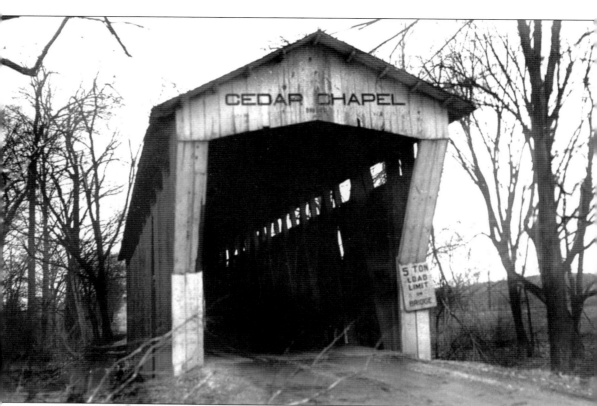

DeKalb County. The entrance to the Cedar Chapel covered bridge in DeKalb County is seen here as photographed by Robert Finnegan around 1947. The bridge was actually about five miles southwest of what were then the boundaries of Auburn. It actually 'bridged' the DeKalb and Hamilton County line as it crossed Cedar Creek. According to a study by the Indiana State Highway Commission, the Howe truss bridge was still operational in the 1930s, although its five ton limit prohibited heavier vehicles. Since the truss of each bridge was vital in determining the load it would support, it was usually fashioned with great care in a field at one end of the bridge site. At the time of construction, large horse-drawn wagons were about as 'heavy' as the bridge traffic ever became.

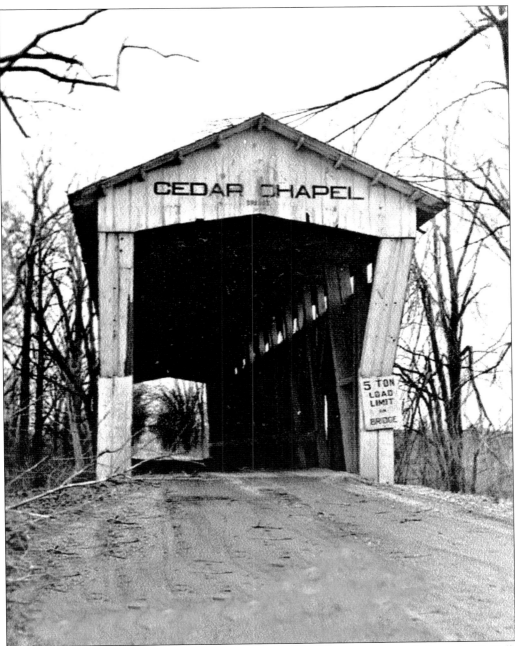

DEKALB COUNTY. Cedar Chapel covered bridge looms into view near Auburn in DeKalb County. This photo was taken by George Aten in the mid-1940s, when the site was still officially listed in the Directory of Covered Bridges of Indiana. It was one of four covered bridges in DeKalb County listed by the state directory. Later, according to the American Society of Covered Bridges, the Cedar Chapel structure was relocated from its original site.

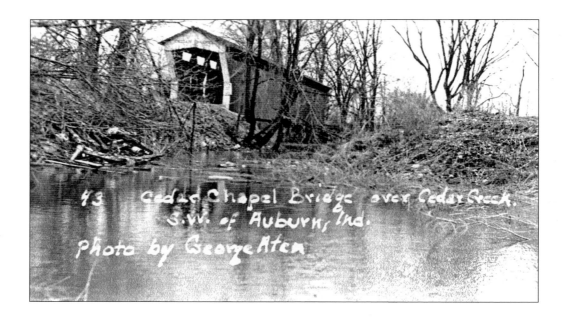

DeKalb County. Pioneer photographer George Aten recorded these two views of the Cedar Chapel covered bridge over Cedar Creek during the 1940s. Aten's journal noted that a number of end-view, long-view, and side-view pictures had been taken for documentation. Aten also noted other DeKalb County covered bridges then standing at Spencerville and northwest of Spencerville, several miles north of Butler.

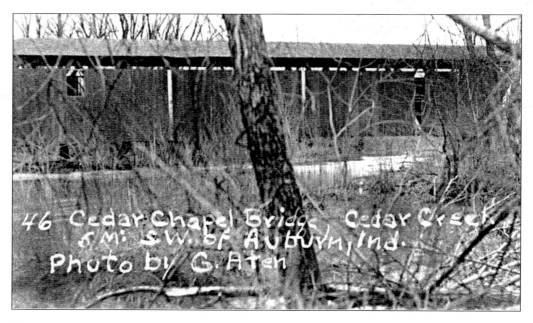

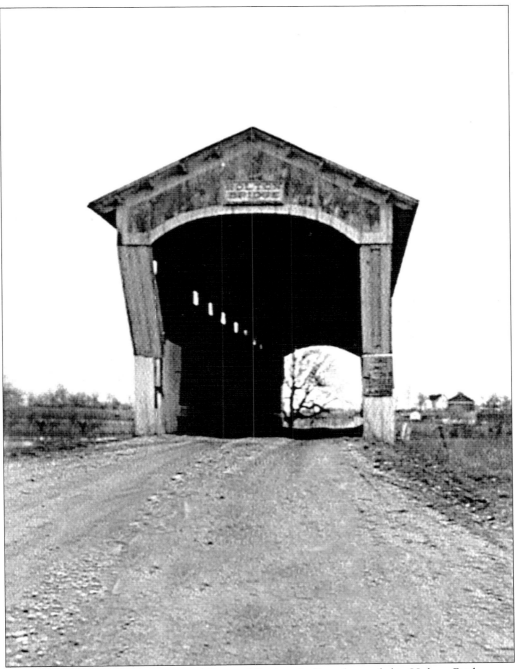

DeKalb County. The Directory of Covered Bridges Indiana located this Holton Bridge over Fish Creek, exactly six miles north of Butler in DeKalb County. During the 1930s and 1940s it had been partially refurbished and was operational for most local traffic. It was photographed by George Aten, who visited hundreds of Indiana sites during the 1940s. The photographer's journal records the covered bridge was "rebuilt" in 1884 after earlier damage.

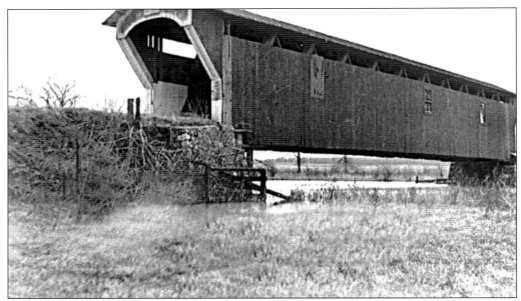

DEKALB COUNTY. The Holton Bridge over Fish Creek in DeKalb County was several miles north of the community of Butler. In 1930, the town of Butler had a population of slightly over 1,600 people, which was about 200 people less than the total had been in 1910.

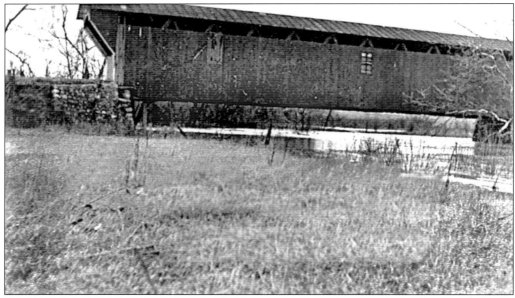

DEKALB COUNTY. Another photograph by George Aten features the Holton Bridge near Butler in DeKalb County. The center truss structure of such covered bridges was initially made of timber that had been hewn from logs which had been allowed to air-season for two to three years. Hemlock and spruce were favored because they were least affected by moisture. Later, pine was heavily in use in Indiana bridges, including imports from Michigan.

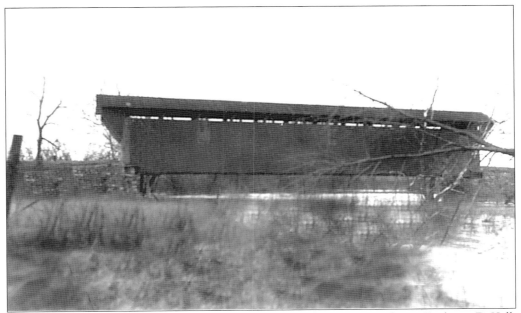

DeKalb County. This is a long view of the Holton Bridge constructed near Butler in DeKalb County. After being rebuilt in the 1880s, the bridge served several more decades into the 20th century. This 1940s photograph was taken by George Aten.

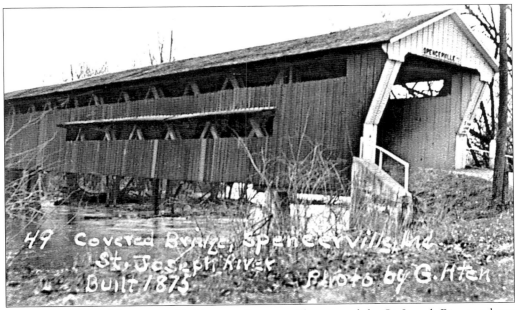

DeKalb County. This covered bridge near Spencerville spanned the St. Joseph River and was built in the early 1870s. Specifically, the bridge was located on Front Street east of Spencerville. During the 1930s and 1940s, the town had a population of around 350 people. This photo was taken by George Aten during the 1940s.

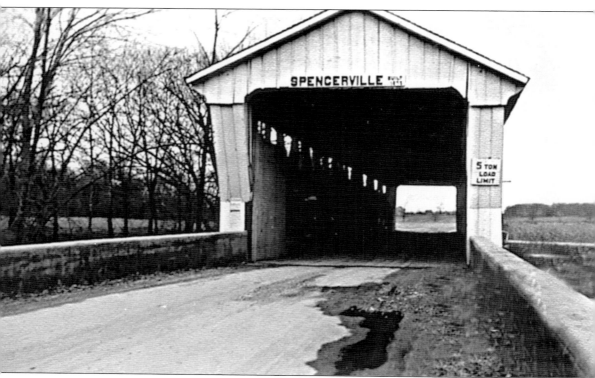

DeKalb County. Shown here is a wide view of the entrance to the Spencerville covered bridge in DeKalb County. This bridge was built in 1873 and spanned 160 feet over the St. Joseph River. This exceptional structure, identified as the Smith #4 design, was fully operational during the 1940s when it was listed in the Directory of Covered Bridges of Indiana. Generally it was referred to as the Spencerville Bridge in connection to the adjoining town; it was also sometimes known as the Coburn Bridge. In this photograph by George Aten, the sturdy bridge had a five ton load limit.

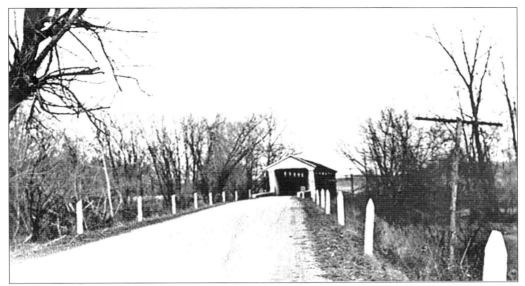

DeKalb County. Another image of the Spencerville Bridge constructed in DeKalb County during the 1870s is seen above. Both the bridge and the roadway appeared to be in very good condition when photographed, around 1948.

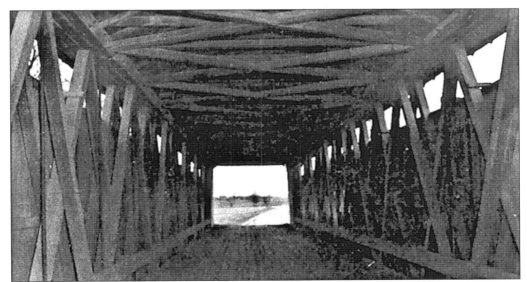

DeKalb County. This is an interior view of the Spencerville Bridge in DeKalb County. Typically the intricate wooden truss structure of the bridge was assembled nearby and then moved out on scaffolding which had been erected in the stream. Such scaffolding had been set in place previously on prepared piers of native stone and mortar. With trusses in position, cross members were put in between them and 'stringers' were added for flooring.

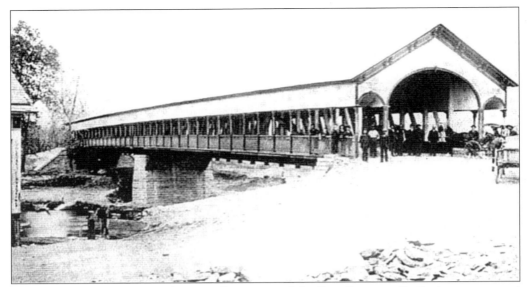

FAYETTE COUNTY. This is a historic illustration of the East Connersville Bridge constructed in 1887 by the legendary A.M. Kennedy and his sons, Emmett Kennedy and Charles Kennedy. It was described by many experts, including Richard Allen Sanders of the American Society of Covered Bridges, as "one of the finest in Indiana." The bridge itself included intricate porch-like sidewalks which, like the center structure, were fully covered.

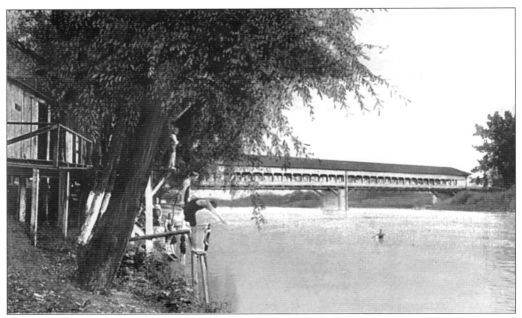

FAYETTE COUNTY. This postcard view shows the 1880s East Connersville Bridge, which spanned the Whitewater River, c. 1920s. The sides of the bridge, which enclosed walkways, were highly ornate with elaborately turned posts and artful Victorian-era designs. Fancy scrollwork was also a trademark of the bridge-building firm of Kennedy and Sons.

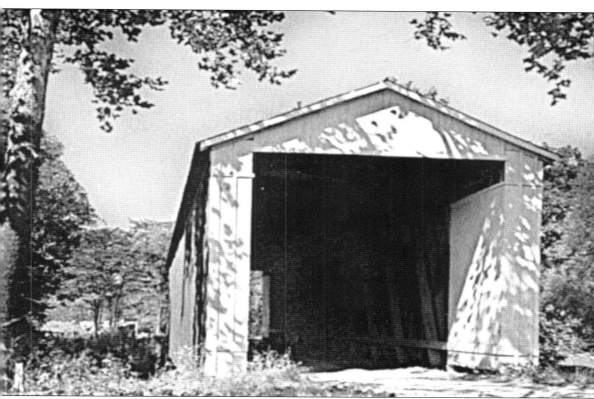

FOUNTAIN COUNTY. Shown here is the charming covered bridge over the Big Shawnee Creek in Fountain County. Known as the Rob Roy Bridge, this sturdy structure extended 105 feet over the waterway. It was built in 1860 in the then-popular Howe truss style. During the early 1940s, the Rob Roy Bridge was listed as still standing in Fountain County. According to the Directory of Covered Bridges of Indiana, the others in this style were located at the southeast edge of Wallace and some three and a half miles southwest of Veedersburg. At Wallace, the bridge crossed Sugar Creek; near Veedersburg the bridge spanned Coal Creek.

FOUNTAIN COUNTY. There was a shaded approach to the covered bridge at the northeast edge of Rob Roy in Fountain County. The bridge spanned Big Shawnee Creek and was of the Howe truss design. It was constructed in 1860 and was 105 feet in length. Photograph by George Aten.

FOUNTAIN COUNTY. Sugar Mill Creek was the site of this covered bridge at the southeast edge of Wallace in Fountain County. During the 1930s, the hamlet of Wallace had little more than 100 people living within its boundaries. The 81-foot bridge was built in 1871.

FOUNTAIN COUNTY. The Wallace covered bridge crossed Sugar Mill Creek in Fountain County. "There are no less than 130 named creeks flowing into the 12 rivers of Indiana," noted Julia Levering in the 1909 book *Historic Indiana*, "besides the many smaller steams which feed these creeks."

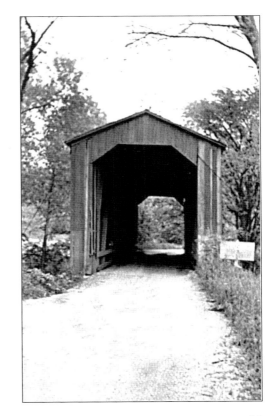

FOUNTAIN COUNTY. This is another view of the Wallace covered bridge at Sugar Mill Creek Fountain County. "All of these waters (creeks), somewhere in their course, flow through picturesque ravines and gorges hung with vines and ferns," added Levering in her early 20th century volume.

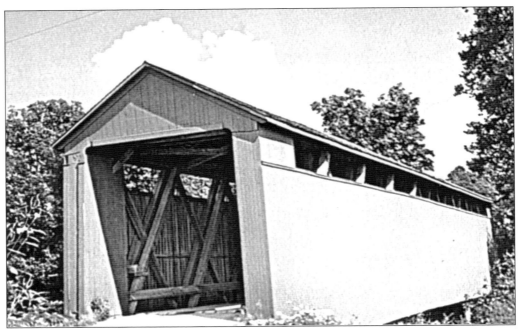

FRANKLIN COUNTY. This rustic covered bridge crossed Salt Creek one-half mile northeast of Enochsburg in Franklin County. The bridge was constructed in the 1870s. Initially the 100-foot span was known as the Stockheughter Bridge. In 1967, it was repainted and reconditioned.

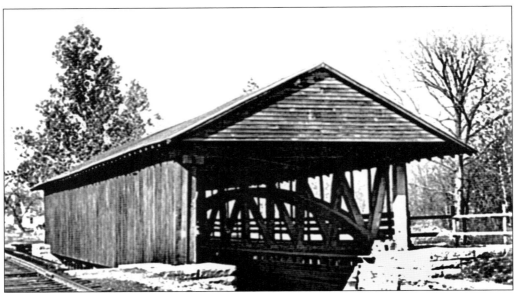

FRANKLIN COUNTY. Pictured here is the remarkable and renowned Duck Creek aqueduct at Metamora in Franklin County. This structure was originally part of the elaborate Whitewater Canal, built in the 1840s. Because it transported water rather than people it was one of the most unique 'covered bridges' in the world. During the late 1940s, it was rebuilt over Duck Creek as part of a state memorial to the Whitewater Canal. It remains the only covered wooden aqueduct still standing in the United States.

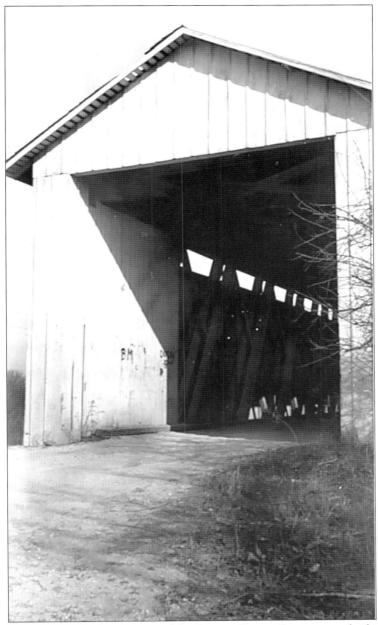

GRANT COUNTY. The Matthews covered bridge in Grant County was built with a very sturdy structure. The bridge was constructed in 1877 on the east edge of Matthews, a spot that later became Third Street. At times called the Cumberland Bridge, or sometimes the New Cumberland Bridge, it was washed down the river during the great flood of 1913. It was eventually 'rescued' and returned on rollers to its original site. Meanwhile, the town of Matthews remained a small community of well less than 500 citizens. In 1940, the bridge at Matthews was listed as the only existing covered bridge in Grant County. However, other records note a number more, including three in Marion, and other Grant County locations including Connor's Mill, Four Mile, Jalapa, and Jonesboro.

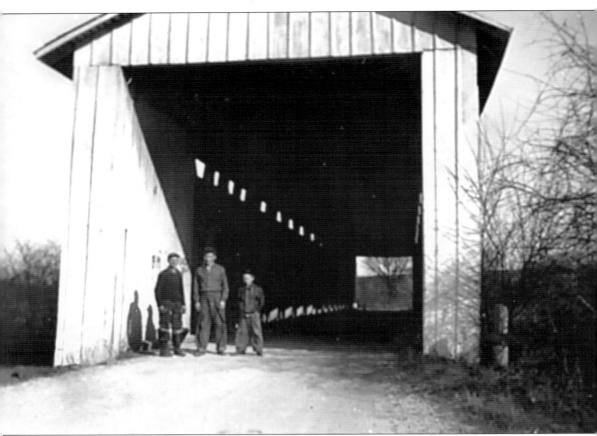

GRANT COUNTY. The Cumberland Bridge at Matthews in Grant County is seen here as it looked in the early 1940s. Completed in 1877, it spanned the Mississinewa River for travelers of that day. It incorporated the Howe truss design, so popular at the time, and extended some 175 feet in length. "Consisting of wooden sheds built over the bridge floors, they served to strengthen the bridges and prolonged their life by keeping them dry," wrote Everett Wilson in *Vanishing Americana*. "One of the most romantic remains of our past is the covered bridge."

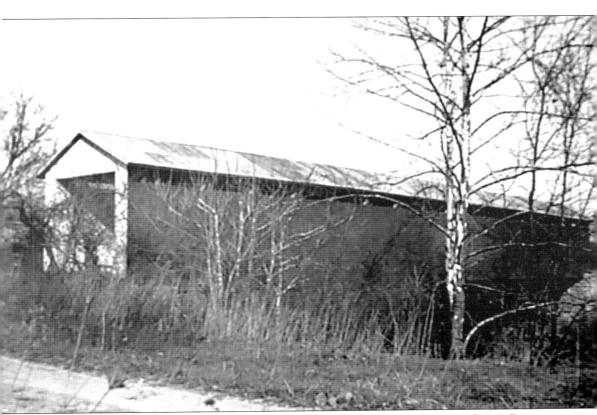

GRANT COUNTY. This is a long view of the covered bridge at Matthews in Grant County. Spanning the Mississinewa River, it was constructed during the late 1870s to aid travel and support commerce in the area. Between the piers or abutments of the bridge, the spans were supported at the side by trusses. Such bridges had an upper and lower chord, with the lower chord rising above floor level. The roofing provided protection to the infrastructure of the truss from harsh weather.

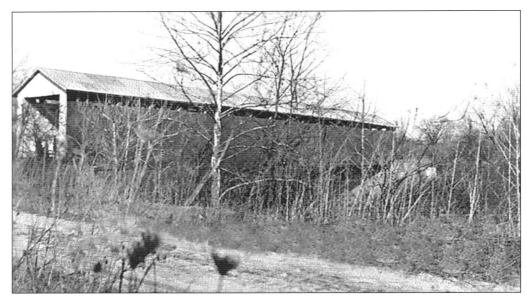

GRANT COUNTY. This photograph of the Cumberland Bridge in Grant County near Matthews was taken by George Aten during the 1940s. Aten repeatedly returned to this site to capture the image of the bridge, often in late winter or early spring.

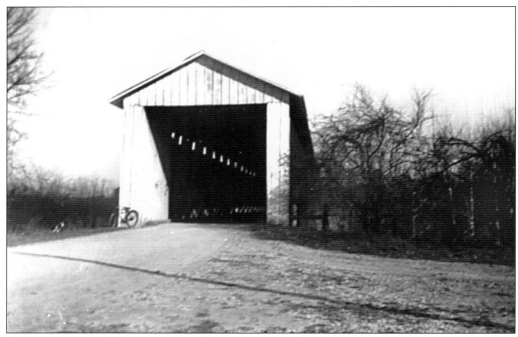

GRANT COUNTY. This is a stark profile of the covered bridge in Grant County near Matthews. A lone bicycle stands at the entrance of the structure, c. 1947. At the time it was officially listed as being on the east edge of Matthews.

GRANT COUNTY. This classic covered bridge served Grant County residents at the east edge of Matthews. Elsewhere in the county, the McFeeley covered bridge also crossed the Mississinewa River.

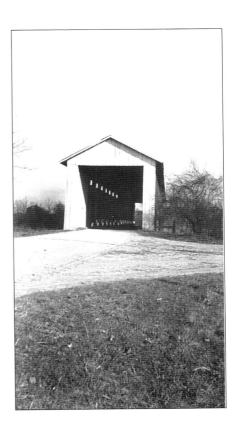

GRANT COUNTY. During the 1940s, photographer George Aten wrote in his journal of this "single span covered bridge, over the Mississinewa River in Grant County, which serves the ghost town of Matthews." Aten also noted at the time that the bridge was already "over 80 years old."

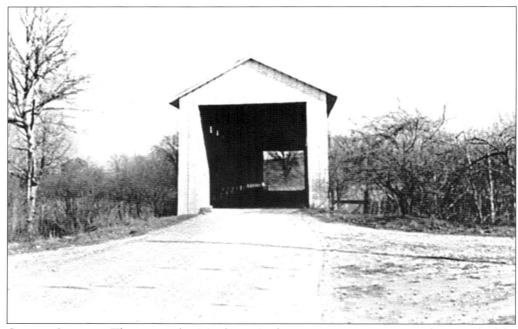

Grant County. This time, the Matthews Bridge in Grant County was photographed by Robert Finnegan who eventually became a leader of the American Covered Bridge Society. Finnegan took this photo around 1948 on his travels from Chicago.

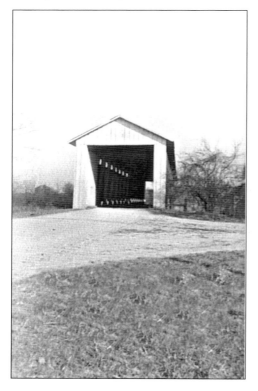

Grant County. This photograph, taken in the late 1940s in Grant County, refers to the new Matthews Bridge as the New Cumberland Covered Bridge. Other accounts say only the Cumberland Bridge, or even the Matthew Bridge. This vintage photo was taken by George Aten.

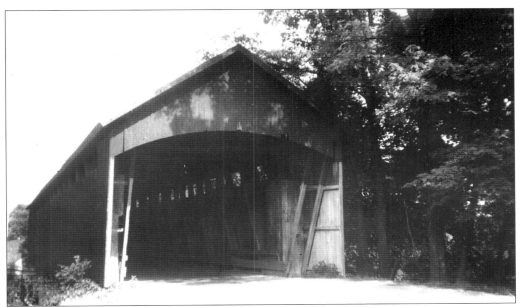

HAMILTON COUNTY. This covered bridge is located in Hamilton County over Little Cicero Creek. The bridge, as listed in the Directory of Covered Bridges of Indiana in 1940, was located just west of Cicero. It was one of only two still-standing covered bridges in that county at the time.

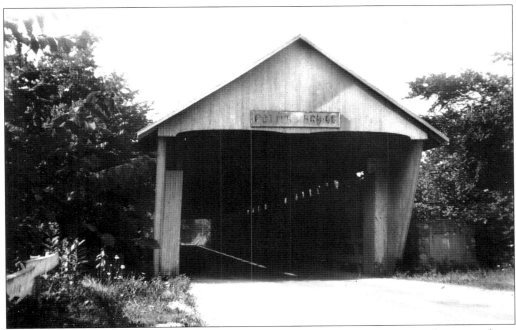

HAMILTON COUNTY. Shown here is the Potter Bridge in Hamilton County. Its original site was listed as one mile north of Noblesville, over the west fork of White River. This Howe truss structure was constructed in 1871 and spanned an amazing 259 feet. Contractors for the bridge were Vernon and Wiles, the engineer for the project was Roy D. Horney. The bridge underwent major restoration in 1937.

HUNTINGTON COUNTY. Two different views of the snow-covered Batson covered bridge reflect the beauty of winter in Huntington County. The magnificent structure spanned the Salamonie River near Warren in the southern portion of the country. Other covered bridges that existed at one time in Huntington County included the Old Red Bridge over the Wabash River in Huntington and the Enos Boyd Bridge, which, like the Batson, also spanned the Salamonie River. For all of their splendor however, none of the Huntington county covered bridges survived long enough to be included in the Directory of Covered Bridges of Indiana which was published in 1940.

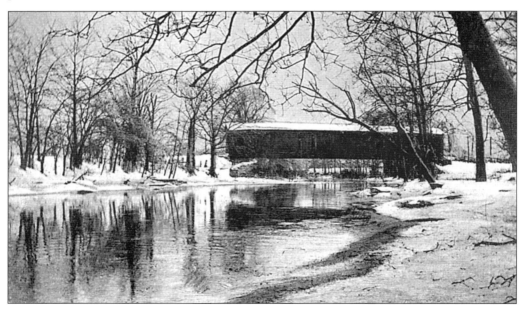

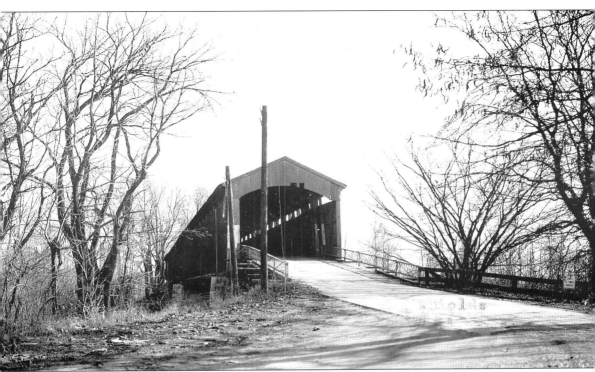

JACKSON COUNTY. A rustic approach to the covered bridge just one-half mile northwest of Brownstown in Jackson County is seen above. The bridge was one of four still standing in that county during the late 1940s. Another such structure was two and a half miles northeast of Brownstown. The others were listed near Seymour and near Medora. The above view was of the north side of the bridge.

JACKSON COUNTY. Ewing covered bridge spanned the east fork of White River in Jackson County. It was one of several similar structures constructed in that area during the 1870s in Jackson County.

JACKSON COUNTY. This is a view of the east side of the covered bridge then two miles northwest of Seymour in Jackson County. This was the only post-truss (without the inner core design) covered bridge in the world. Known as the Bell's Ford Bridge, it spanned 325 feet over the east fork of White River. Photographer George Aten wrote in his journal during the mid-1940s that the Seymour area bridge "serves very heavy traffic and will probably be the first to come down in the county."

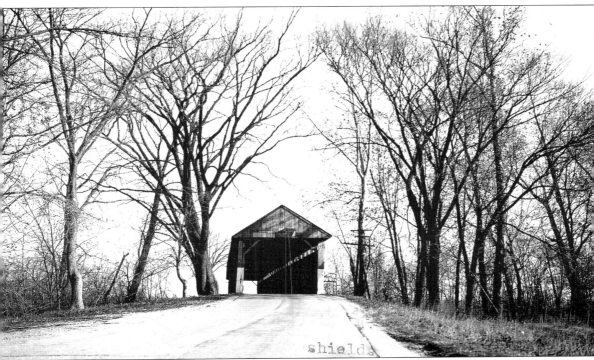

JACKSON COUNTY. The approach to the covered bridge then located some two miles west of Seymour in Jackson County is seen here. This view from the 1940s shows the west side of the historic bridge. In 1940, the Directory of Covered Bridges of Indiana put this structure just northwest of the town, one of four still standing in the county at the time. Two others included in the listing were northwest and northeast of Brownstown; a third was located just east of Medora. Long before the directory had been published there had also been covered bridges at Crothersville, Houston, and Newry in Jackson County. Still another covered bridge was situated at Milport on the Jackson and Washington County line. It spanned the Muscatatuck River, as did the bridges at Crothersville and Newry.

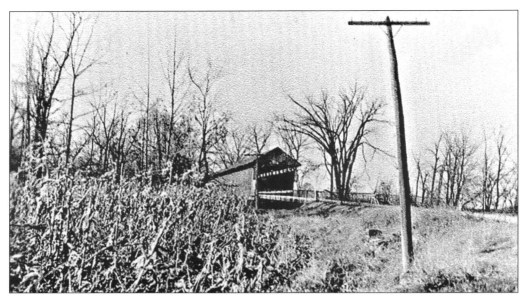

JACKSON COUNTY. This is a 1940s scene of a covered bridge two miles west of Seymour in Jackson County. Seen here is the east end of the exceptional bridge as photographed by George Aten.

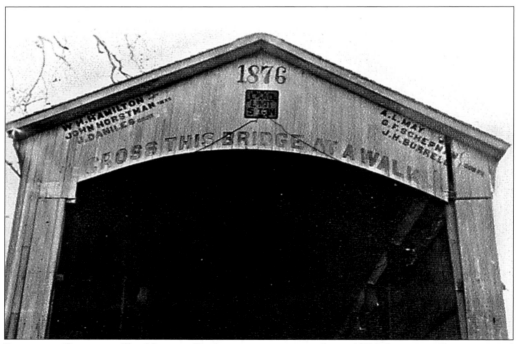

JACKSON COUNTY. Shieldstown Bridge was constructed in 1876 between Seymour and Brownstown in Jackson County. This Burr arch design spanned the east fork of White River and extended some 231 feet. When photographed in the 1940s, George Aten noted its condition in his journal. "This is the north side," wrote Aten. "The south side would be a waste of film as it is overgrown with weeds and is covered with smoke as the B. & O. runs a train within 100 feet of it."

JAY COUNTY. Seen here is a long since vanished covered bridge at Bryant in Jay County. This vintage postcard from the Portland Office Supply documents a bridge which is omitted from most lists, including the Directory of Covered Bridges of Indiana.

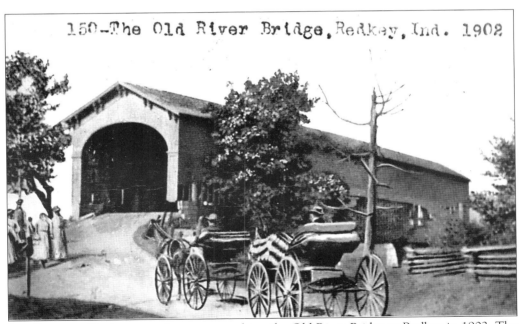

JAY COUNTY. Carriages are shown approaching the Old River Bridge at Redkey in 1902. The scene suggests an Independence Day (Fourth of July) celebration in the community. This Jay County covered bridge was constructed in 1872 and was ultimately replaced in 1906.

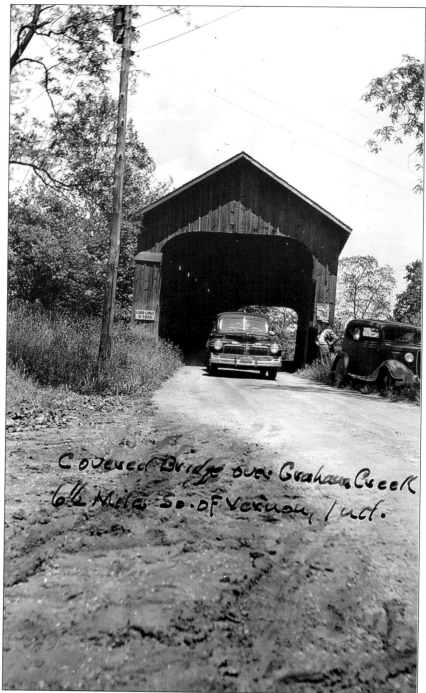

JENNINGS COUNTY. Two vintage automobiles sit at the entrance of the covered bridge over Graham Creek in Jennings County. This bridge, sometimes known as the James Bridge, was constructed six and one-half miles south of Vernon utilizing the Howe truss design. Built in 1887, it was 124 feet in length. This photograph was taken during the 1940s by George Aten

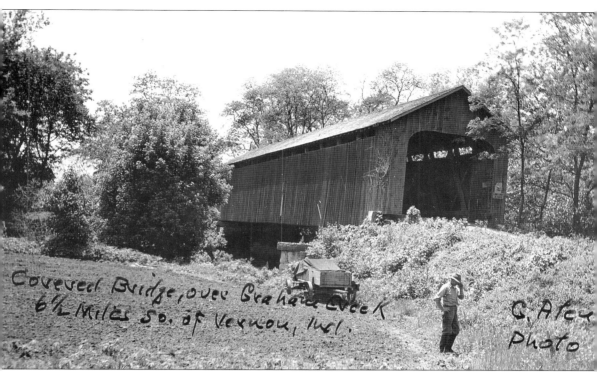

JENNINGS COUNTY. An unidentified man pauses behind a farm wagon in a field near the entrance to a Jennings County covered bridge. This scene was captured during the 1940s by photographer George Aten. The bridge crossed the Graham Creek and was located just over six miles from the town of Vernon. About the time this photo was taken, the Vernon community had a population of around 425 people. During that decade a second Jennings County covered bridge was still standing near Scipio.

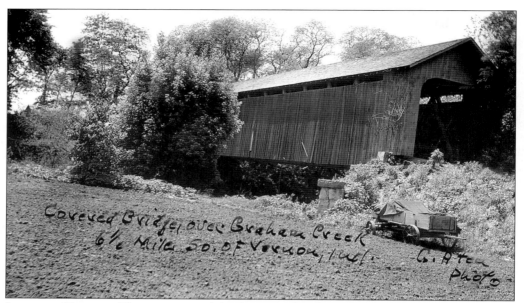

JENNINGS COUNTY. This is a view of the James Bridge, located six and one half miles south of Vernon in Jennings County. Constructed in 1887, it spanned Graham Creek (or Graham's Creek) and extended 124 feet.

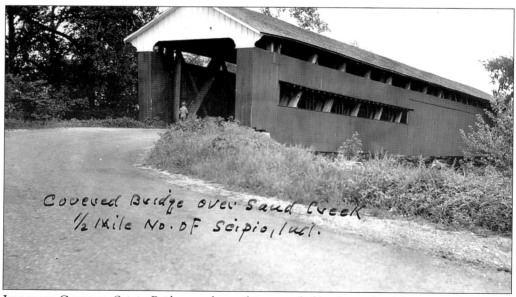

JENNINGS COUNTY. Scipio Bridge was located just one-half mile north of the town of Scipio in Jennings County. It crossed Sand Creek with a length of 124 feet. Made in the Howe truss design, it was erected at that site in 1886. This photograph was taken in the 1940s by George Aten.

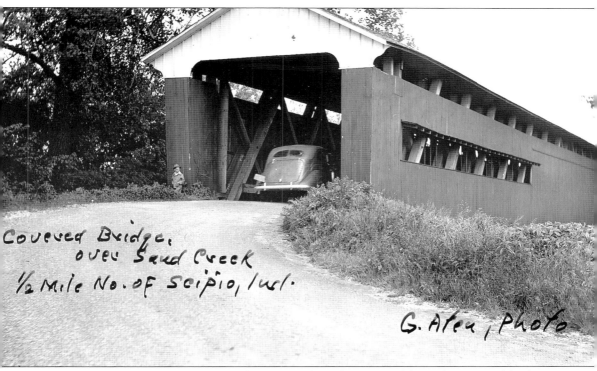

JENNINGS COUNTY. While an automobile fits easily within the width of this covered bridge near Scipio in Jennings County, ever-wider trucks were becoming a problem. In 1947, about the time this picture was taken, a national magazine declared of such covered bridges, "their designers did not foresee the day when square-shaped motor trucks would go through them, and, as a consequence, some of those entrances have suffered considerable damage." This particular bridge had been repainted and somewhat repaired shortly before this photograph by George Aten was taken.

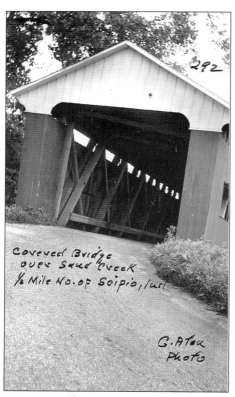

JENNINGS COUNTY. Seen here is a closer view of the Scipio Bridge over Sand Creek in Jennings County. The interior was of Howe truss design and assembled on ground near the bridge before being fitted to the bridge's base and then roofed over. George Aten photograph.

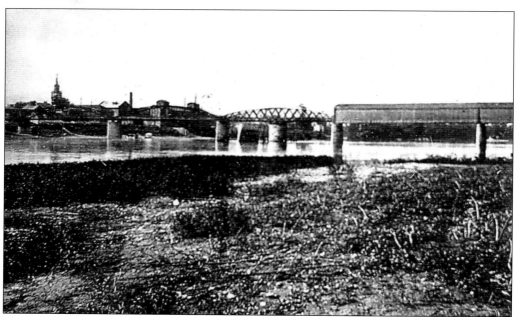

KNOX COUNTY. This was the Main Street Bridge connecting Indiana and Illinois over the Wabash River in Vincennes. This Knox County covered bridge disappeared long before statewide efforts to preserve covered bridges were underway in the 1930s and 1940s.

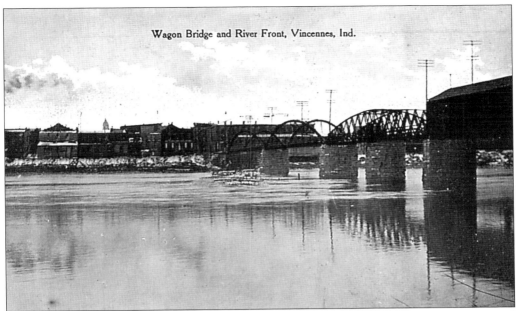

KNOX COUNTY. Wagon Bridge and River Front at Vincennes in Knox County are pictured here. This is an early 1900s postcard view of the covered bridge and other bridge structures crossing the Wabash River.

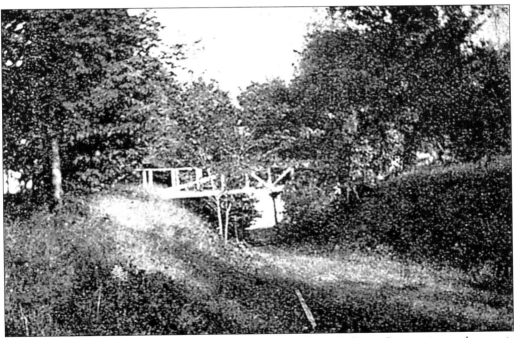

LAPORTE COUNTY. The small covered bridge at Pine Lake in LaPorte County is seen here as it looked about 1905. While the county once had several smaller covered bridges, including one over the west branch of Trail Creek, none were listed in the state's official Directory of Covered Bridges of Indiana at the end of 1940.

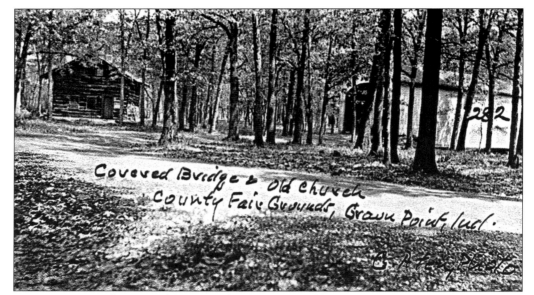

LAKE COUNTY. The covered bridge and old church at the Lake County fairgrounds in Crown Point are pictured here. This structure was originally built in Rush County in 1878. It was moved to Lake County in 1935.

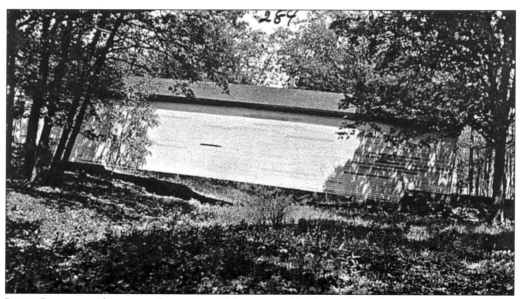

LAKE COUNTY. Above is a closer view of the covered bridge at the Lake County fairgrounds as it looked in the mid-1940s, some 10 years after it had been relocated there. Both Lake County photographs on this page were taken by George Aten.

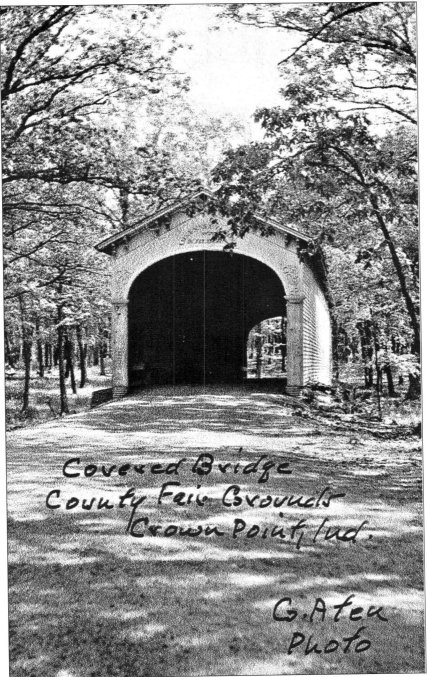

LAKE COUNTY. After a long trip from Rush County, this covered bridge arrived in Lake County during the Great Depression of the 1930s. The 85-foot span was first disassembled near its original site in Milroy, then it was shipped to its new location on the Lake County fairgrounds in Crown Point. There it was reassembled, painted cream with red trim, and preserved for public display. At the fairground it covered a waterless section of the park.

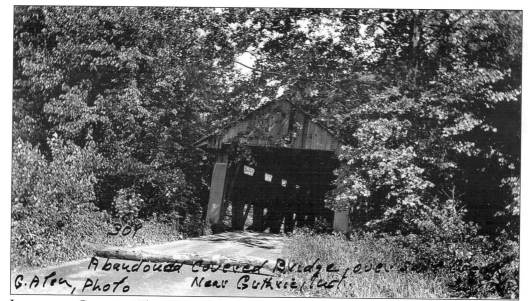

LAWRENCE COUNTY. This covered bridge was already abandoned when 'discovered' by photographer George Aten near Guthrie in Lawrence County during the 1940s. It once spanned Salt Creek.

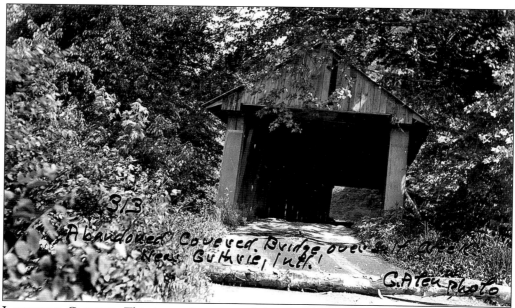

LAWRENCE COUNTY. This is another view of the abandoned Lawrence County bridge near Guthrie. In the Directory of Covered Bridges of Indiana it was listed as being five miles north of Bedford.

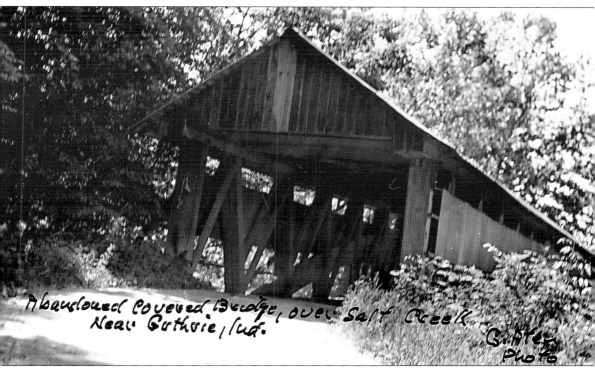

LAWRENCE COUNTY. Guthrie Bridge spanned Salt Creek in Lawrence County. It was sometimes referred to as the Red Bridge or Harrel's Ford Bridge. The 1940 Directory of Covered Bridges of Indiana listed it among three covered bridges in Lawrence County. Another was near Tunnelton, and a third was over the east fork of White River west of Williams. This photograph was taken by George Aten during the 1940s when he reported it in his journal as "abandoned."

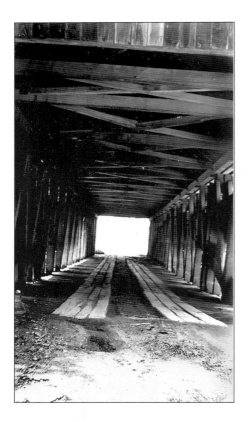

LAWRENCE COUNTY. This is an interesting interior image of the Guthrie Bridge in Lawrence County. The wooden structure inside the covered bridge remained essentially intact in the 1940s long after it had been abandoned by county officials.

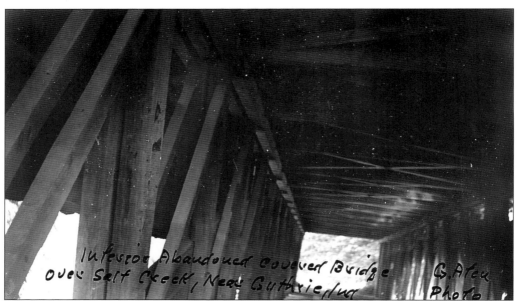

LAWRENCE COUNTY. Photographer George Aten provided this image of the inside of the Guthrie Bridge in Lawrence County decades ago. Although abandoned at the time, the timbers were still remarkably well preserved in the 1940s.

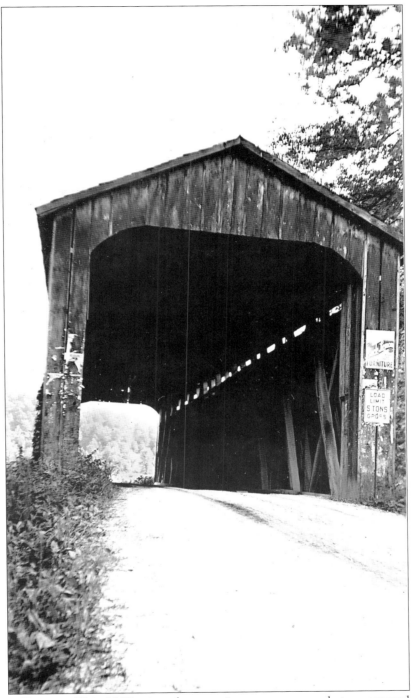

LAWRENCE COUNTY. This 1940s view shows a picturesque approach to a covered bridge in Lawrence County. Existing bridges at Tunnleton, Guthrie north of Bedford, and Williams were photographed as they stood by photographers George Aten and Robert Finnegan. The portal of this bridge bears a sign announcing a five ton load limit as well as a furniture advertising sign.

MARION COUNTY. Here is the covered bridge on Washington Street in Indianapolis as it looked in the 1890s. This Marion County structure crossing White River was one of the largest such bridges in Indiana. Initially it was known as the National Road Bridge but was later simply identified as the Washington Street Bridge. During the 1830s the Indiana state legislature spent the staggering sum of $18,000 for the structure which was contracted by the legendary builder Lewis Wernwag. Historians suggest it was not the famed Wernwag himself but his sons, William and Lewis Jr., who actually supervised the construction based on their father's detailed plans. Despite its elaborate construction, the bridge came to an unpleasant end. "Unhappily, with the passage of years the grand bridge became a victim of neglect," wrote Robert Allen Sanders in *Covered Bridges of the Middle West*. "Unsavory characters lounged in the pedestrian passages so that they had to be barricaded. Buffeted by countless wagons for 72 years, the ornate entrance posts were reduced to splinted stumps. A last indignity was the use of the structure for advertising, with signs extolling the virtues of gum, tobacco, and buggies."

MARION COUNTY. This covered bridge was located just north of Fort Harrison in Marion County where it spanned Mud Creek. In July of 1947 photographer George Aten took these pictures of the bridge. Above, his own personal vehicle is parked at the entrance of the bridge. Aten referred to it in his journal as the Ft. Harrison Bridge, although other records identify it as the Mud Creek Bridge. The Directory of Covered Bridges of Indiana gave it no name at all in 1940, but included a vague location along with six others still standing in Marion County. Other locations included Southport, Julietta, West Newton, northwest of Oaklandon, west of Oaklandon, and Traders Point.

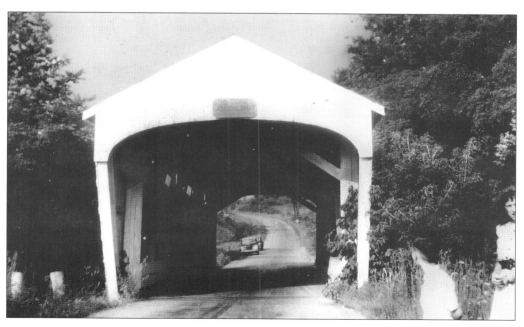

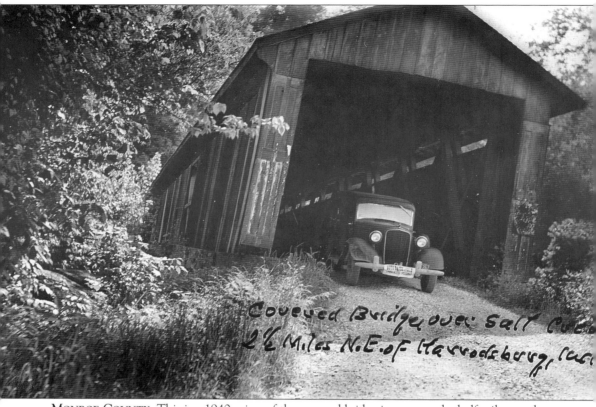

MONROE COUNTY. This is a 1940s view of the covered bridge just two and a half miles northeast of Harrodsburg in Monroe County. The automobile bears a bumper sticker promoting racing events in Lawrence County. This bridge structure was one of four in Monroe County which spanned Salt Creek. Others were located near Harrodsburg or south of Bloomington. Interestingly, photographer George Aten pinpointed this bridge some two miles closer to Harrodsburg than the official Directory of Covered Bridges of Indiana published a few years earlier.

MONROE COUNTY. Above is another view of the covered bridge over Salt Creek northeast of Harrodsburg in Monroe County. This bridge was seldom used when photographed in the 1940s, although it was still largely intact. There were four covered bridges in the county at the time, located at sites north and east of Harrodsburg.

MONROE COUNTY. Photographer George Aten noted this covered bridge was two and a half miles northeast of Harrodsburg in Monroe County, however the Directory of Covered Bridges of Indiana listed only a bridge four and a half miles northeast of Harrodsburg.

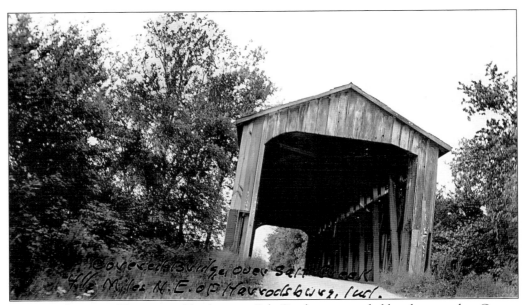

MONROE COUNTY. This covered bridge over Salt Creek was recorded by photographer George Aten as the one four and a half miles northeast of Harrodsburg. This site corresponds with the listing in the Directory of Covered Bridges of Indiana, however, it does not explain the bridge two miles closer noted by Aten.

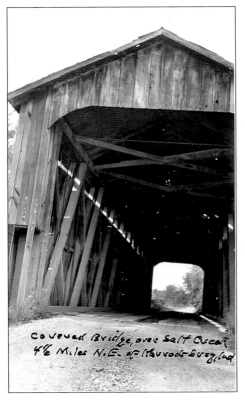

MONROE COUNTY. The interior of this covered bridge less than five miles from Harrodsburg in Monroe County appeared in fairly good shape when photographed during the 1940s. However, at that point in time, after many decades of service, the bridge saw very little vehicle traffic.

MONROE COUNTY. This particular covered bridge spanned Clear Creek in Monroe County. One listing put it "just north" of Harrodsburg. Here, photographed in the 1940s by traveling photographer George Aten, it appears in relatively poor condition compared to the Salt Creek covered bridge.

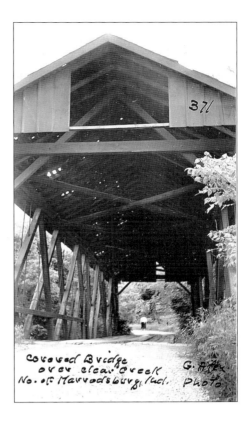

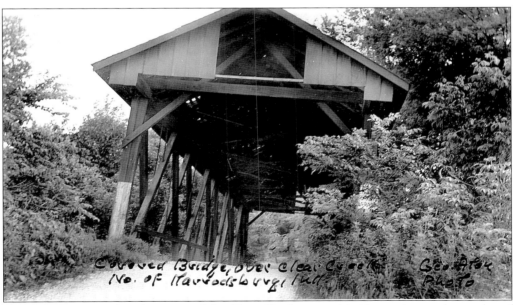

MONROE COUNTY. Another view of the Clear Creek covered bridge at the northern edge of Harrodsburg in Monroe County. The community had a population of just about 400 people when this photograph was taken in the early 1940s.

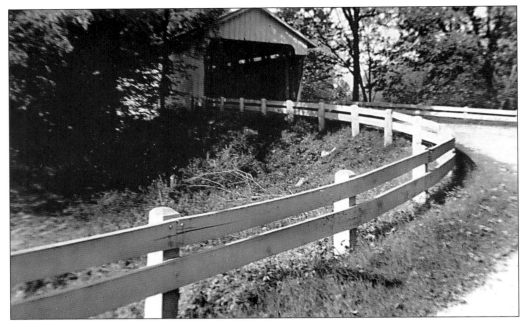

MONTGOMERY COUNTY. A wooden fence leads to the entrance of the Darlington covered bridge in Montgomery County. In the 1940s a local historian wrote that a committee began the selection of a "practical bridge builder" in 1867. According to the account, "donations totaling $1,585 had been made by the men of the community, and the balance of the money was appropriated by the county commissioners. Richard Epperson was appointed superintendent of construction and the building contract was awarded to Joseph Kress."

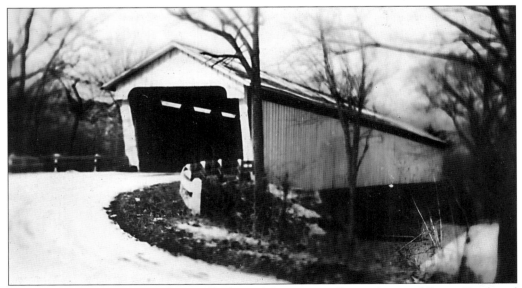

MONTGOMERY COUNTY. Darlington Bridge in Montgomery County spanned Sugar Creek and was of Howe truss design. During the mid-1940s a correspondent wrote, "it is one of the few remaining covered bridges and is in daily use as the only passage way north west of Darlington across Sugar Creek."

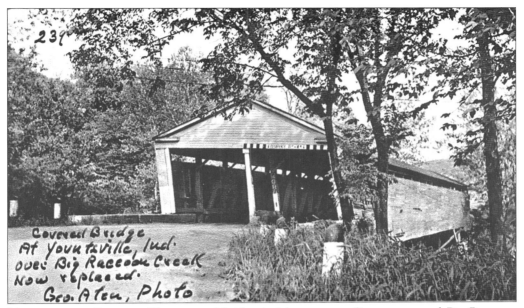

MONTGOMERY COUNTY. The covered bridge in Montgomery County spanned Big Raccoon Creek. Photographer George Aten identified it at Yountsville, however the Directory of Covered Bridges of Indiana lists it just east of Ladoga. The Yountsville bridge spanned Sugar Creek but the Ladoga bridge ran across Big Raccoon Creek.

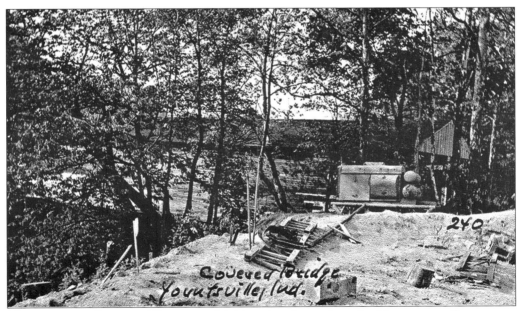

MONTGOMERY COUNTY. The covered bridge site shown here in Montgomery County was described in the 1940s as "being replaced." Photographer George Aten specified it as being at Yountsville but there are indications it may have been at the Ladoga site at Big Raccoon Creek.

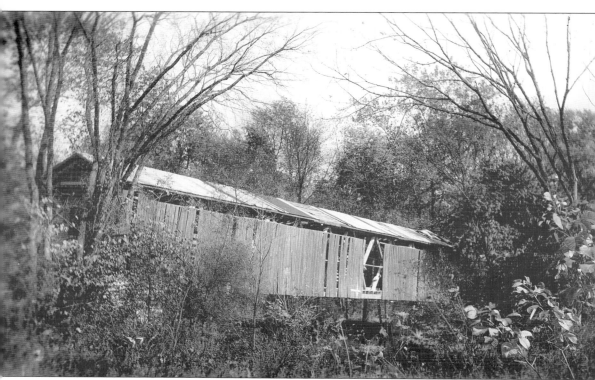

OWEN COUNTY. The Cataract Falls covered bridge in Owen County was at one time one of the most famous and photographed in the United States. Constructed in 1876 over Mill Creek, the 140-foot bridge became a national symbol of the beauty of covered bridges. In 1947, it was one of the sites singled out by the American Covered Bridge Society. The following year an 8 by 10 inch color photograph of the bridge was offered as the first prize in the national organization's membership contest. During the 1940s, the Directory of Covered Bridges of Indiana described it as being located just northeast of the town of Cataract. The community itself claimed a steady population of 150 citizens.

OWEN COUNTY. Cataract Falls covered bridge in Owen County is seen here. This photograph was taken by Robert Finnegan in the late 1940s. In a message on the back of the photograph, Finnegan explains to fellow photographer George Aten that he was planning a move to Chicago which would delay their meeting.

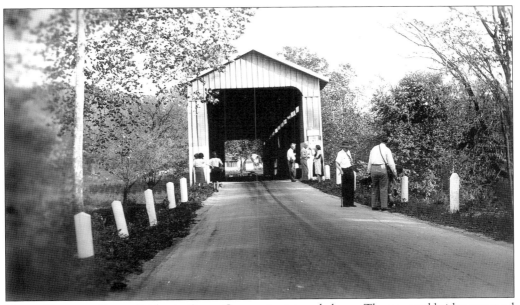

OWEN COUNTY. Cunot Bridge in Owen County is pictured above. The covered bridge spanned a branch of the Eel River then known as Mill Creek. Various lists also identify it as the Cunot Bridge or Croy Mill Bridge. It was located in the 1940s state directory as being one half mile southwest of Cunot.

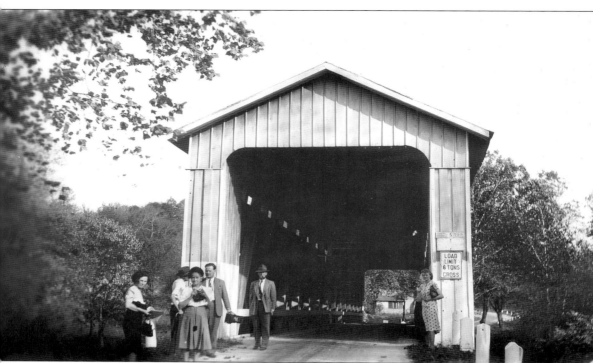

OWEN COUNTY. An apparent abundance of tourists are shown visiting the Cunot covered bridge in Owen on a lovely afternoon in the late 1940s. Still fully operational at the time, a sign at the entrance warned of a load limit of six tons. Besides Cunot and Cataract, other Owen County covered bridges existing at the time were located at Freedom and at Gosport. Covered bridges at Cunot and Cataract crossed Mill Creek. Bridges at Freedom and Gosport spanned the west fork of White River.

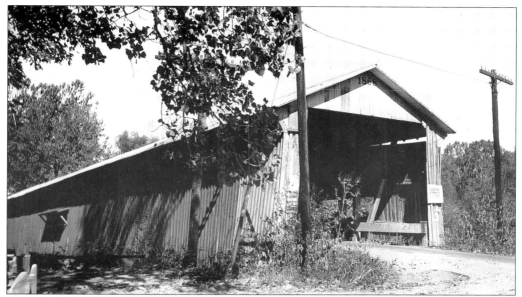

PARKE COUNTY. Bridgeton covered bridge in Parke County was built in 1868 over Big Raccoon Creek. The two-span structure was 245 feet long and a classic example of the Burr arch type of design. A water-powered mill which used heavy stones for grinding flour stood near the bridge at the time of its construction. This view shows the bridge shortly after it was fully repaired in 1940.

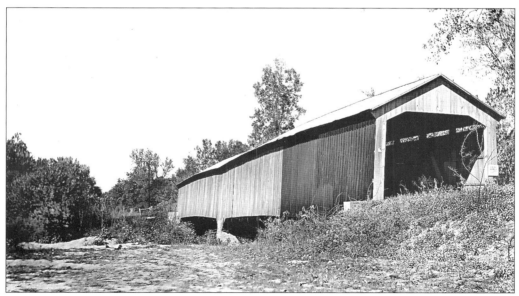

PARKE COUNTY. Jeffries Ford Bridge was listed as two miles southwest of Bridgeton in Parke County by the Directory of Covered Bridges of Indiana. This is how it appeared in 1940s. The two-span arch truss structure was built in 1915 over Big Raccoon Creek and was over 200 feet long. This photograph was taken by George Aten.

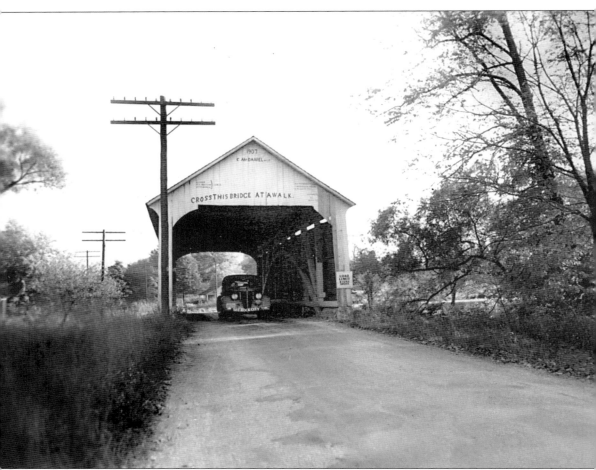

Parke County. This enchanting image of the north side of the Catlin Bridge in Parke County shows how it looked through the lens of photographer George Aten around 1947. The bridge itself had been erected some 40 years earlier just one and a half miles from the town of Catlin. Of the Burr arch design, it extended 54 feet. Later it was removed from this postcard-perfect setting to a new home on the Parke County Golf Course just off U.S. Highway 41 near Rockville. Today it is currently part of the nationally acclaimed Parke County Covered Bridge Festival held every October.

Parke County. The approach to the Catlin Bridge in Parke County is pictured here c. 1940. The bridge stood near the community of Catlin, which boasted a population of 151 around the time this black and white photograph was taken. The bridge originally crossed Sunderland Creek before being moved years later to the Parke County Golf Course near Rockville.

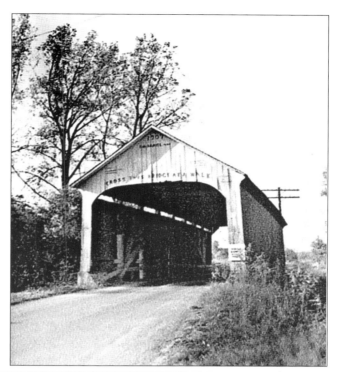

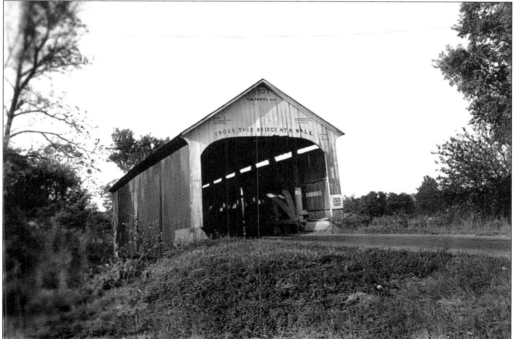

Parke County. The south end of the Catlin covered bridge in Parke County is seen here. This photograph was taken in the latter 1940s by photographer George Aten who traveled extensively through the state during that decade in an attempt to record existing covered bridges.

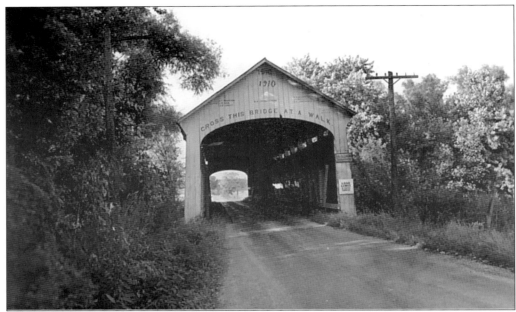

PARKE COUNTY. Jessup covered bridge in Parke County is shown here as viewed from the south end. Located just north of the hamlet of Jessup, the bridge spanned the Little Raccoon Creek. The single-span Burr arch structure was built in 1910 and extended 155 feet.

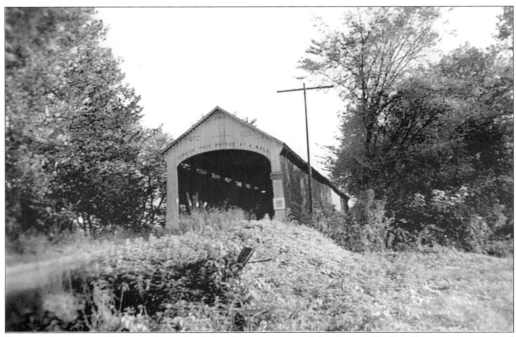

PARKE COUNTY. The north end of the Jessup covered bridge in Parke County is pictured as it looked to travelers in the late 1940s. This black and white photograph was taken by photographer and historian George Aten who recorded hundreds of Midwestern covered bridges before the middle of the 20th century.

PARKE COUNTY. This image of McAllister's Bridge in Parke County was photographed by Robert Finnegan during the 1940s. Constructed in 1914, the site of the bridge was some five and one-half miles southeast of Rockville, spanning Little Raccoon Creek. The single-span Burr arch bridge was 122 feet long.

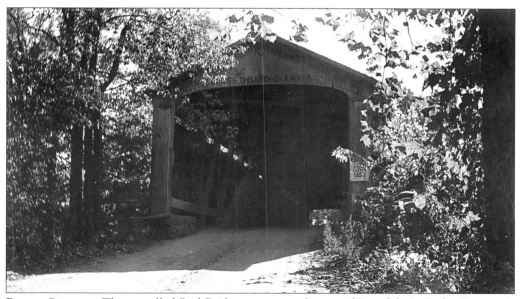

PARKE COUNTY. The so-called Red Bridge was one mile east of Rosedale in Parke County. It was constructed by J.J. Daniels, one of the better known bridge builders of that era, in 1880. It crossed Big Raccoon Creek and is now a distinguished part of the Parke County Covered Bridge Festival held every October.

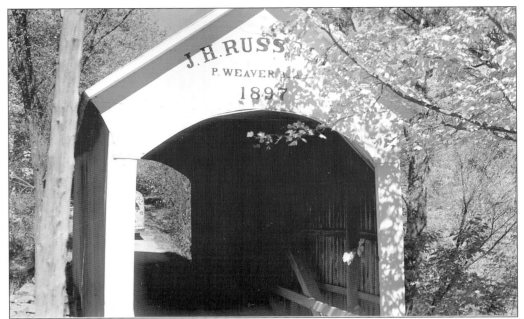

Parke County. J.H. Russell Bridge is seen here on private property in Parke County. It is shown as photographed by Robert Finnegan, official of the American Covered Bridge Society, during the 1940s. The bridge itself was built in 1897 over Square Rock Branch by P. Weaver. The structure, now privately owned, was of the Queen post design and 42 feet in length. It is the shortest bridge in Parke County which is considered the covered bridge center of the United States.

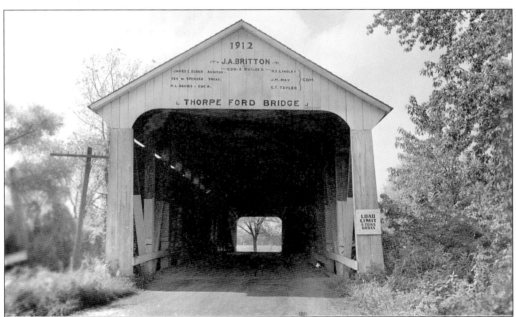

Parke County. The east end of the distinguished Rosedale or Thorpe's Ford Bridge in Parke County is seen here during the 1940s. Located just one mile east of Rosedale, it spanned Big Raccoon Creek. The structure was built by J.A. Britton in 1912 and became a landmark.

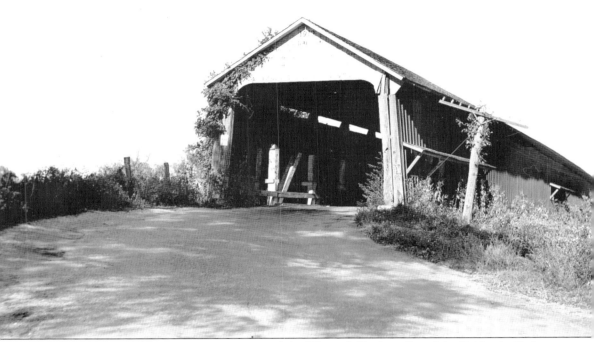

PARKE COUNTY. This is an inspiring view of the Thorpe's Ford, or Rosedale, Bridge in Parke County. Built in 1912 and located a short distance from Rosedale, the bridge was the project of Joseph A. Britton. Bridge-builder Britton was actually born in Parke County near Rockville and was a prisoner of war as a member of the Union Army during the Civil War. He later practiced law. Britton's first bridge was over the narrows of Sugar Creek near the Lusk Mill. Ultimately Britton built more than 40 covered bridges during the late-19th century and into the early-20th century, especially numerous in Putnam, Parke, and Vermillion counties of Indiana.

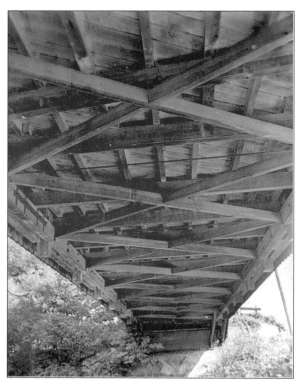

Parke County. This is a unique underneath view of the Thorpe Ford Bridge in Parke County. The complex arrangement of timbers was still in remarkable condition in this photograph taken during the 1940s. Located near Rosedale, the bridge was solidly constructed in 1912 with a Burr arch inside structure.

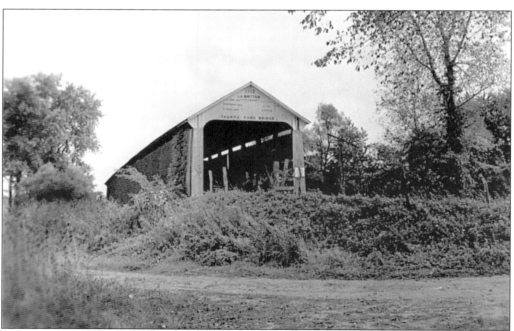

Parke County. This is a west view of Thorpe Ford covered bridge near Rosedale in Parke County. This rustic scene was captured in a photograph taken around 1947 when there was little traffic around the remarkable structure.

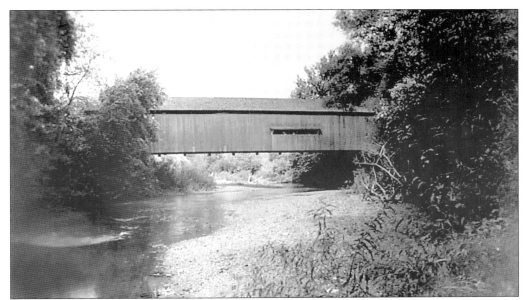

PARKE COUNTY. Above is a splendid view of Big Raccoon Creek in Parke County as it flowed beneath the Thorpe Ford covered bridge in the 1940s. The bridge itself was still memorable some 40 years after it had been constructed.

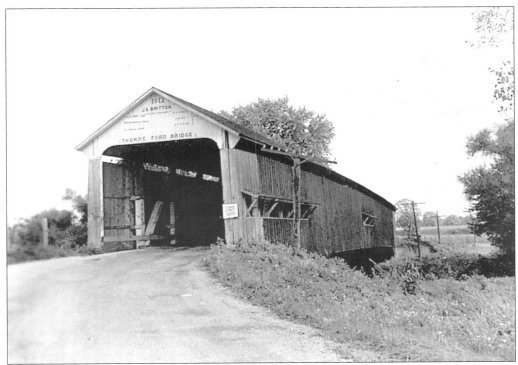

PARKE COUNTY. This was the west side view of the Thorpe Ford covered bridge in Parke County as photographed by George Aten during the 1940s. The bridge was pictured shortly after it had been repaired and refurbished after many years of service.

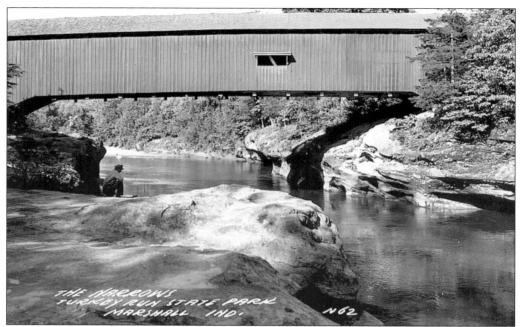

PARKE COUNTY. Here we have an early-1950s view of the covered bridge at the Old Mill site in Turkey Run State Park near Marshall in Parke County. This structure spanned Sugar Creek with a Burr arch design and a mass of very sturdy timbers.

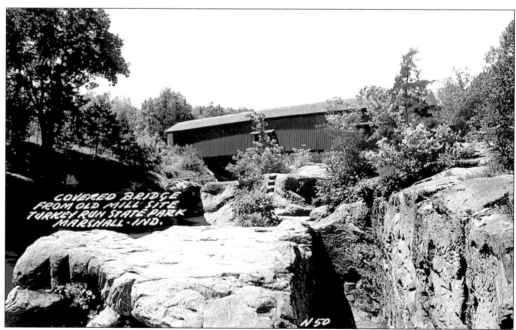

PARKE COUNTY. The legendary Narrows covered bridge over Sugar Creek at Turkey Run State Park near Marshall is seen above. Built in 1882, it spanned 121 feet using the then-popular Burr arch design. This black and white photo postcard image was posted in October of 1951.

PUTNAM COUNTY. The covered bridge over Mill Creek in Putnam County is pictured above. Sometimes known as the Parker Bridge, it was located three and one-half miles east of Cloverdale. The bridge was built in 1915 and is shown here about 30 years later with a group of visitors dressed in their Sunday best for the occasion. This sweeping view was taken by photographer George Aten, who traveled to many of Indiana's covered bridges during the 1940s, assembling a treasure trove of vintage black and white illustrations.

PUTNAM COUNTY. Seen from the opposite side as the previous photo, the Parker Bridge, located three and one-half miles east of Cloverdale in Putnam County, as it looked during the 1940s.

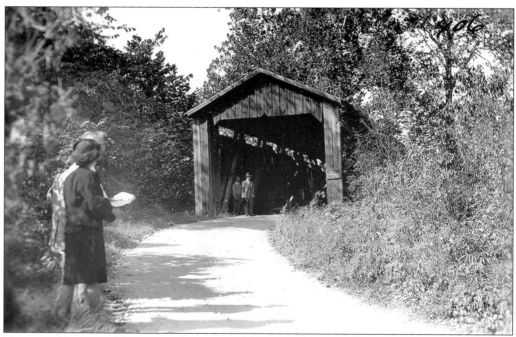

PUTNAM COUNTY. Here is another covered bridge near Cloverdale in Putnam County. This bridge was located just three miles southeast of Cloverdale. It was one of several in the vicinity which spanned Mill Creek in that county.

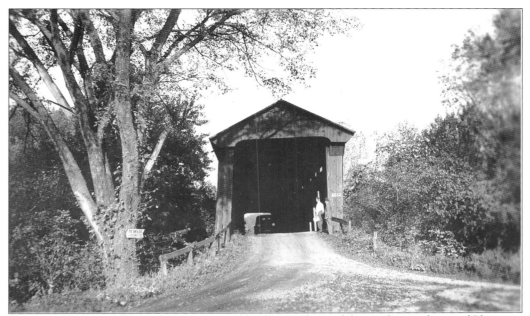

PUTNAM COUNTY. This endearing covered bridge was located four miles southeast of Pleasant Gardens in Putnam County. Despite a directional sign for Brazil posted on a nearby tree, the scene remained very natural and rustic. Julia Levering observed in the 1909 volume *Historic Indiana*, ". . . wild flowers cluster along the banks, and all about splendid elm trees stand, and stately green thorn trees fling their fern-like foliage about."

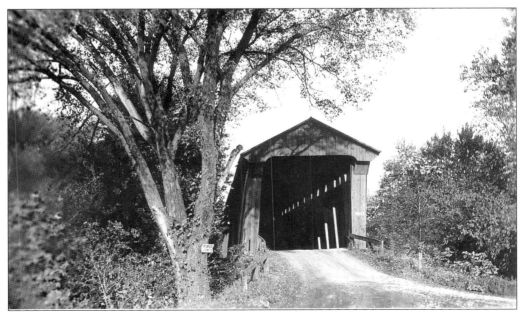

PUTNAM COUNTY. The approach to the covered bridge in Putnam County near Pleasant Gardens is seen here as it looked in the 1940s. The bridge, which spanned Deer Creek, was still well-maintained and in seemingly excellent condition.

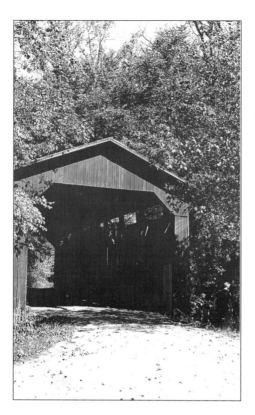

PUTNAM COUNTY. Craple Bridge over Croy's Creek in Putnam County was located about five miles south of Pleasant Gardens. It was constructed in 1889 and was one of many covered bridges still operating during the early 1940s in Putnam County.

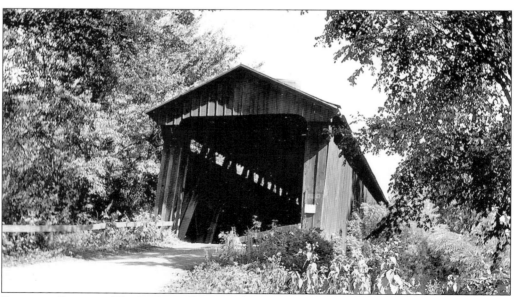

PUTNAM COUNTY. The Dick Huffman Bridge over Big Walnut Creek in Putnam County is pictured above. Located three miles southeast of Pleasant Gardens, the structure was erected in 1880 using the Howe truss design. It was 265 feet long.

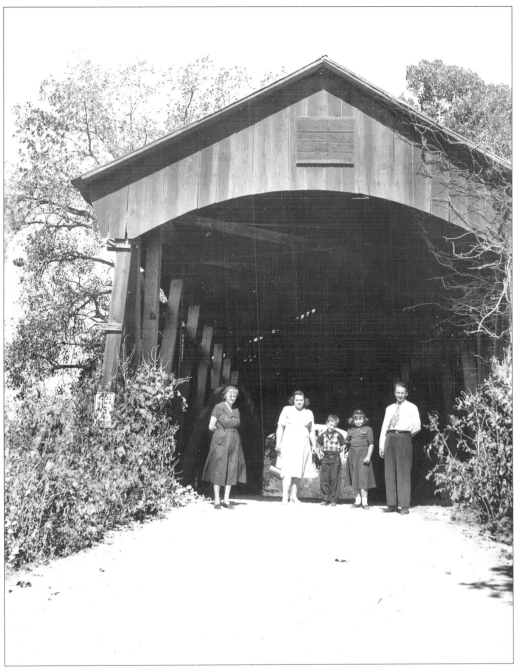

PUTNAM COUNTY. Friends and family gather for a photograph at the entrance of the covered bridge near Manhattan in Putnam County. Then only a half mile away from the community itself, the bridge spanned Deer Creek. This photograph was taken in the 1940s shortly after the publication of the Directory of Covered Bridges of Indiana by the Indiana Historical Society. As early as the 1930s, a statewide effort was underway to preserve and protect the remaining Hoosier covered bridges.

Putnam County. This pastoral scene shows the approach to the covered bridge at Putnamville in Putnam County. This bridge crossed Deer Creek. A five ton load limit was posted at the entrance of the bridge when this photograph was taken in the 1940s.

Putnam County. This side view of the Putnamville covered bridge shows Deer Creek flowing below. While some bridges were replaced in the 1940s, including a Putnam County structure near Cloverdale, this Putnamville Bridge was still in use during the World War II decade.

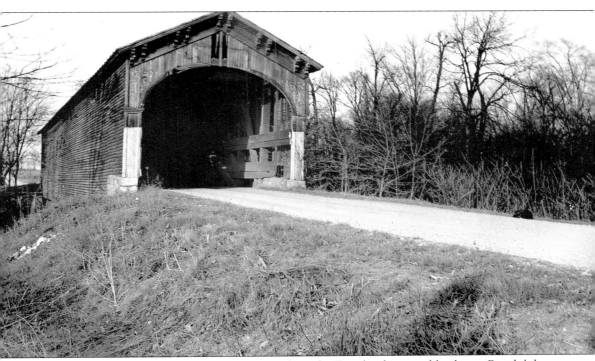

RANDOLPH COUNTY. This view of the approach to the Farmland covered bridge in Randolph County shows how it appeared when the bridge was in fairly good condition during the 1940s. Officially listed as one mile southwest of Farmland, it crossed the west fork of White River. In the spring of 1883, the commissioners of Randolph County contracted the extraordinary bridge builder A.M. Kennedy and Sons to construct three wooden bridges. The first one was to be across the White River southwest of Farmland. It was to be 120 feet long. The other two covered bridges were to cross the Mississinewa River in Green Township.

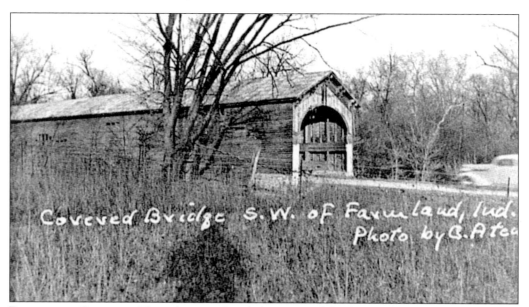

RANDOLPH COUNTY. This photograph of the covered bridge southwest of Farmland in Randolph County was taken by George Aten. "This single span of Burr truss design will soon be discarded," wrote Aten in his late 1940s personal journal. "A main super-highway is under construction two miles away."

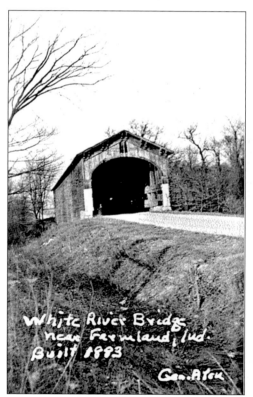

RANDOLPH COUNTY. White River covered bridge was constructed in 1883 near Farmland in Randolph County. This late-1940s photograph was taken by historian and photographer George Aten. Both the roadway and the bridge appear to have been in good condition at the time.

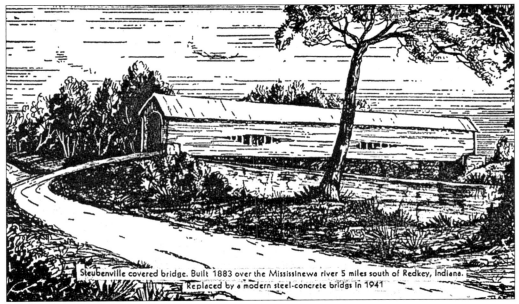

Steubenville covered bridge. Built 1883 over the Mississinewa river 5 miles south of Redkey, Indiana. Replaced by a modern steel-concrete bridge in 1941

RANDOLPH COUNTY. Steubenville Bridge is located some five miles south of Red Key in Randolph County. The Muncie Star reported in July of 1941 that the covered bridge was being replaced with a $92,000 steel-concrete structure. "The covered wooden bridge which is being demolished has served not only as a traffic handler and place of shelter from storms," noted the newspaper in that issue, "but as an advertising medium as well. Many pairs of initials bound by a heart have been gouged into the timbers by many a sharp knife. Patent medicine advertising and faded pictures of political candidates are a part of the bridge. Painted on one of the huge beams are advertising for Kistleman overalls at 45 cents a pair."

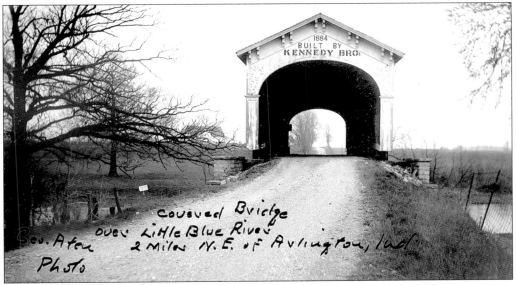

RUSH COUNTY. The covered bridge two miles northeast of Arlington in Rush County is seen here as photographed by George Aten during the 1940s. The Kennedy Brothers builders are clearly identified on the portal of the bridge.

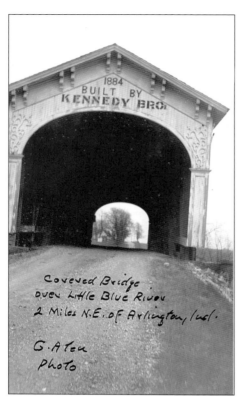

Rush County. Offutt Ford Bridge is located two miles northeast of Arlington in Rush County. The structure was built in 1884 by the Kennedy Brothers firm and spanned 98 feet over the Little Blue River. This photograph was taken during the 1940s by photographer George Aten.

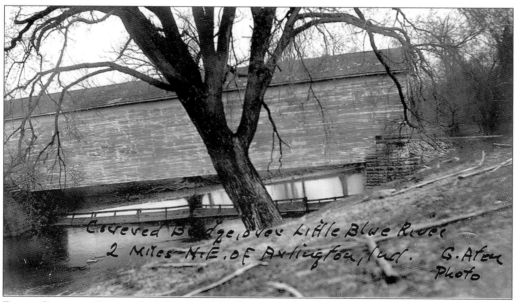

Rush County. Burr arch Offutt Ford Bridge in Rush County was erected near the town of Arlington during the 1880s. After that, prolific bridge-builder A.M. Kennedy left the business to his sons, Emmett and Charles, and the partnership lasted briefly before Emmett Kennedy assumed full operation of Kennedy Brothers.

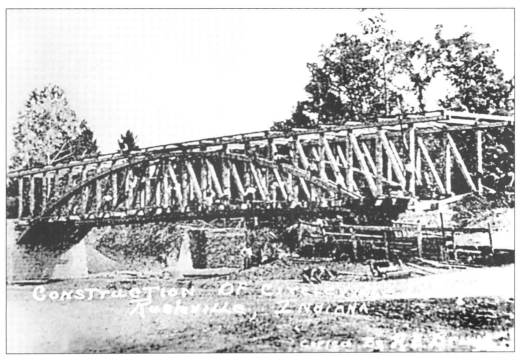

RUSH COUNTY. Construction in 1892 of Circleville covered bridge in Rush County just south of Rushville is seen above. Reportedly, builder A.M. Kennedy eventually installed sidewalk ceilings on the bridge at his own expense. It became one of the few in the Hoosier state to be completed with fancy arched portals and fully covered arcaded sidewalks. It underwent major renovation as early as 1945.

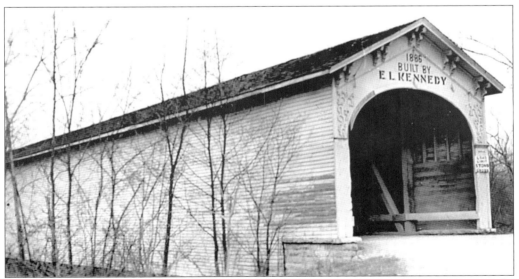

RUSH COUNTY. The Moscow covered bridge in Rush County was built by Emmett Kennedy, son of famed builder A.M. Kennedy, in 1886. The mighty structure extended an amazing 334 feet over Big Flat Rock River.

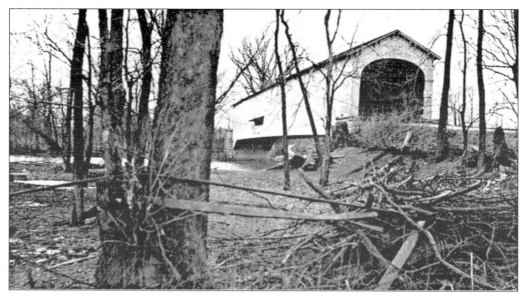

RUSH COUNTY. This covered bridge was located two and one-half miles north east of Moscow in Rush County. The Moscow Bridge crossed Big Flat Rock River with a traditional Burr arch design. In the 1940s, photographer George Aten described this view as the "left end" of the Moscow Bridge.

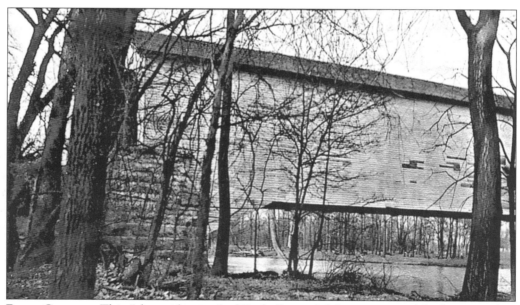

RUSH COUNTY. This "close side view" of Rush County's Moscow covered bridge was taken around 1948 by George Aten. In Aten's journal, the photographer noted that the sides of the historic bridge, after more than half a century of weathering, were in need of repair.

RUSH COUNTY. Here is a striking 1940s view of the covered bridge then officially two miles west of New Salem in Rush County. It spanned the Little Flat Rock River.

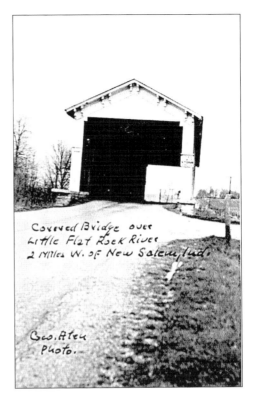

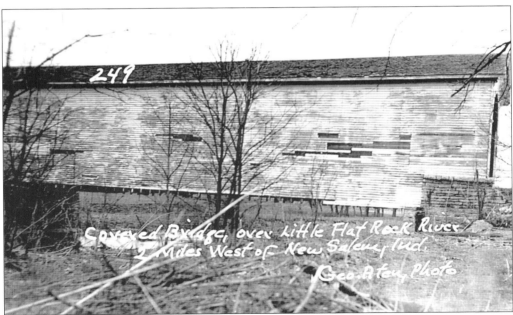

RUSH COUNTY. The New Salem covered bridge in Rush County needed some repairs around 1948. This view of the very long bridge was taken by historian and photographer George Aten who traveled to the sites of hundreds of Indiana covered bridges before 1950.

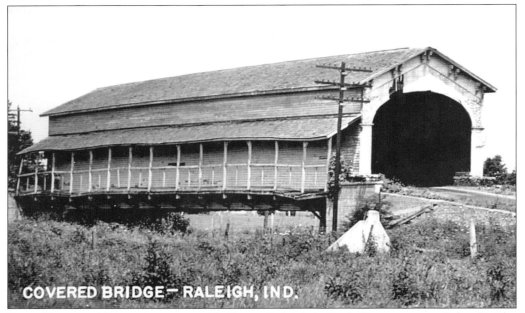

Rush County. This unique covered bridge at Raleigh in Rush County spanned the Big Flat Rock River and is shown here as photographed in the late 1940s by Robert Finnegan.

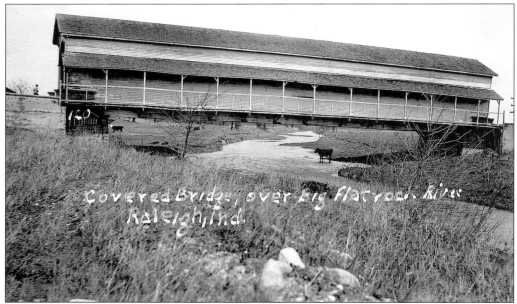

Rush County. This view of the covered bridge in Rush County's Raleigh was taken by photographer George Aten. Writing in his journal around 1948, Aten noted the bridge sat "in the heart of town at Raleigh. It was built by the Kennedy family, famous Indiana covered bridge builders." Aten concluded that the bridge, after 70 years, was "still in active service."

RUSH COUNTY. Photographer George Aten found this covered bridge "abandoned" during his travels in Rush County during the 1940s. The bridge was located at the edge of Rushville and crossed the Big Flat Rock River.

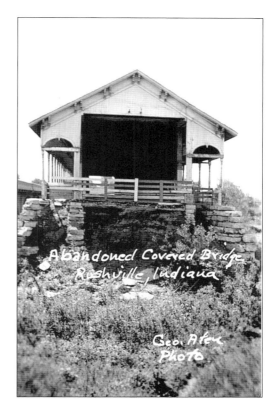

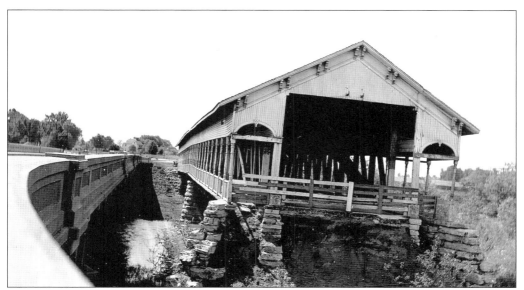

RUSH COUNTY. Above is a fuller view of the "abandoned" covered bridge at Rushville in Rush County in the late 1940s. At the left, a new concrete bridge is shown replacing the older bridge. The scene was photographed and recorded in the journal of photographer George Aten.

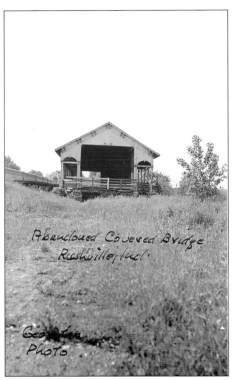

Rush County. This distant view of the Rushville covered bridge in Rush County was taken during the late 1940s. A replacement concrete bridge is shown just to the left of the wooden structure. Both structures cross Big Flat Rock River.

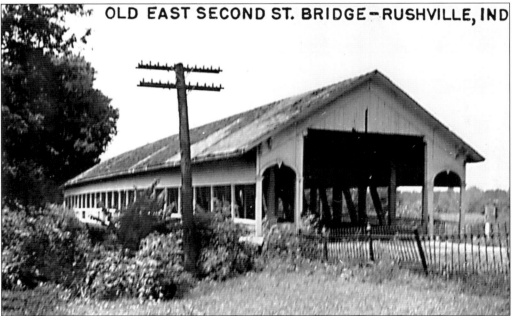

Rush County. Old East Second Street Bridge at Rushville in Rush County is seen above. This photograph was taken while the remarkable covered bridge was still in operation. It was one of twelve listed as still in use in Rush County in 1940 according to the Directory of Covered Bridges of Indiana.

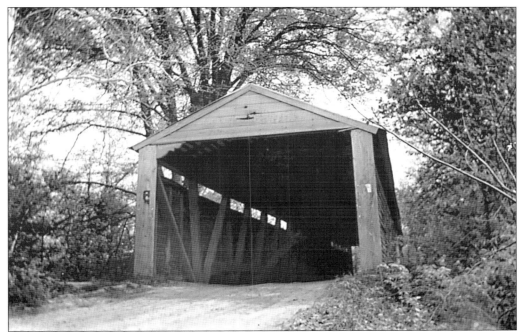

SPENCER COUNTY. Huffman Mill covered bridge over Anderson Creek at the Spencer County and Perry County line is seen here. When this photograph was taken in the 1940s, the Directory of Covered Bridges of Indiana listed a second Spencer County covered bridge over Anderson Creek one mile north of New Boston; it was sometimes known as the Shoals Bridge. The American Society of Covered Bridges reported in 1945 that the bridge near New Boston had been mislocated "by at least a mile" in some unnamed listings, causing many to think it no longer existed.

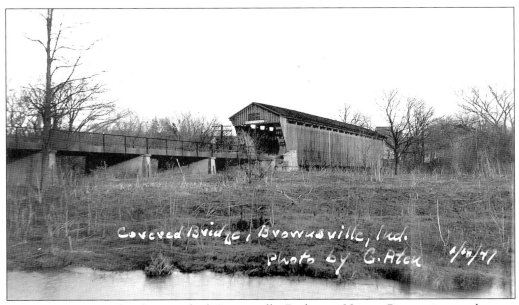

UNION COUNTY. The distinguished Brownsville Bridge in Union County is seen here as photographed by photographer and historian George Aten in early 1947.

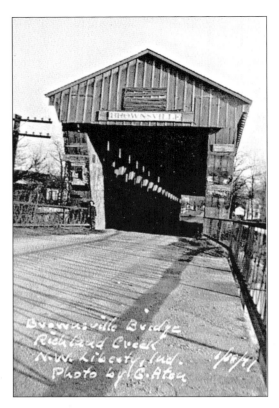

UNION COUNTY. Brownsville Bridge in Union County is pictured as it looked during the 1940s. The photographer identified this bridge as spanning Richland Creek. However, the state bridge directory at the time put the Liberty Bridge over Richland Creek and the Brownsville Bridge over the east fork of White River.

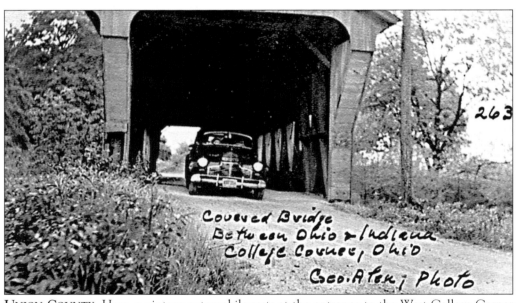

UNION COUNTY. Here, a vintage automobile rests at the entrance to the West College Corner covered bridge in Union County. The bridge spanned Four Mile Creek from the Indiana state line to the Ohio state line. Some listings count it as only a half covered bridge for the Hoosier state.

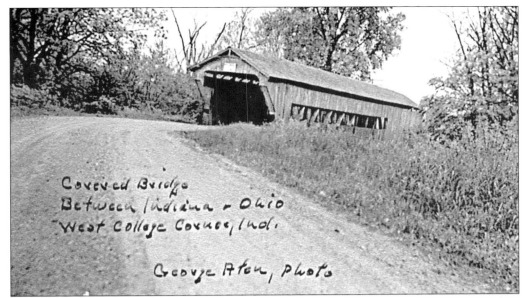

UNION COUNTY. West College Corner covered bridge in Union County crossed the state line between Indiana and Ohio. In 1945, The America Society of Covered Bridges counted it as only a half bridge for Indiana, explaining "its upkeep is shared by Preble County, Ohio."

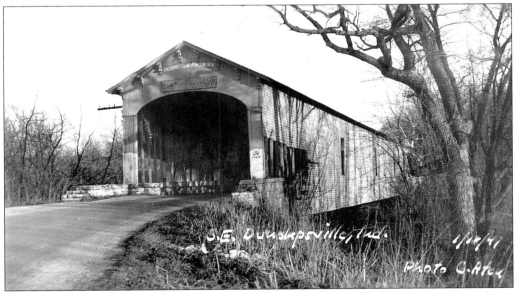

UNION COUNTY. A covered bridge southeast of Dunlapsville in Union County is seen here. In the 1940s, it was described as "still standing" over the east fork of the Whitewater River. The noted Archibald Kennedy began bridge-building with this project in 1870. In 1948, the nationally distributed Covered Bridge Timber newsletter proclaimed: "it is still in use and has two 150 foot spans."

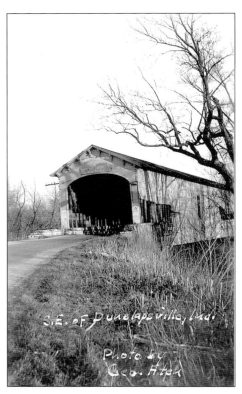

UNION COUNTY. Dunlapsville covered bridge in Union County launched the career of builder A.M. Kennedy. "The fine workmanship that went into the bridge was immediately apparent to anyone who crossed it," according to author Richard Allen Sanders, who wrote numerous books on covered bridges nationwide, "and word soon got around the state that Arch Kennedy, and his boys down in Rushville could toss up a top-notch covered bridge."

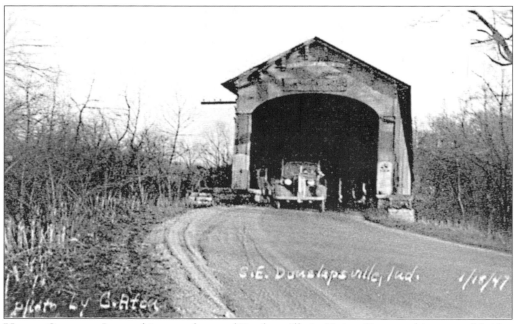

UNION COUNTY. Located just southeast of Dunlapsville in Union County, this covered bridge was still functioning fine in 1947 when photographed by Hoosier-land traveler George Aten. It was one of five still operational at the time in Union County.

UNION COUNTY. This covered bridge at Dunlapsville in Union County even came with a tale of romance. Reportedly, A.M. Kennedy was aided in the building of this bridge by son Emmett. While father and son were staying at the nearby farmhouse of Mr. and Mrs. Isreal Freeman, Emmett fell madly in love with the Freeman's daughter, Martha. Shortly after the bridge was completed in 1870 Emmett and Martha were married and made their home in Rush County.

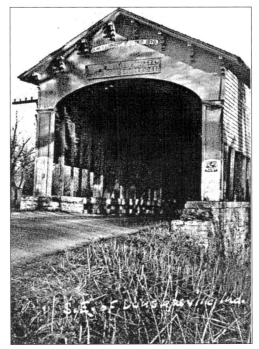

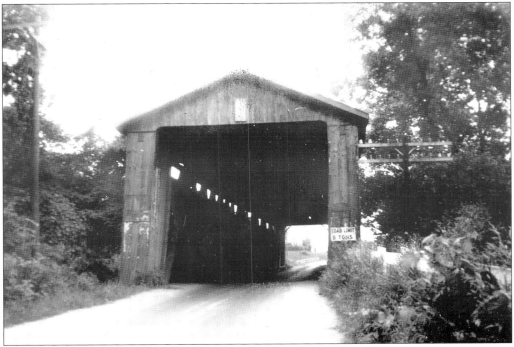

UNION COUNTY. Liberty covered bridge near the town of Liberty in Union County is seen above. It crossed Richland Creek about two miles northwest of the Liberty community. This black and white photograph was taken in August of 1947 when it was still fully operation and in fairly good condition.

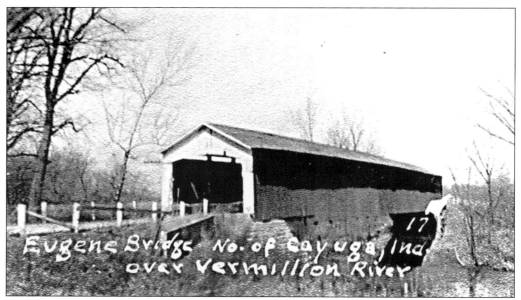

VERMILLION COUNTY. Eugene Bridge, over the Vermillion River in Vermillion County, is pictured here. It was constructed in the latter half of 19th century using the Burr arch design. It extended for 192 feet across the river and was located one mile north of Cayuga. When this photograph was taken in the 1940s, Cayuga had a population of just over 1,100 people.

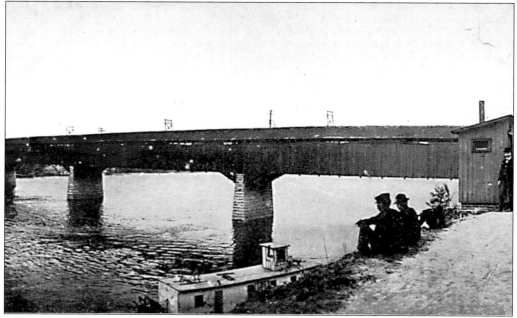

VIGO COUNTY. Old Wagon Bridge at Terre Haute in Vigo County is seen here. This image appeared on an early 1900s postcard issued by C.U. Williams of Bloomington, Illinois. The double-barreled (two lane) structure was the longest span ever erected by builder J.J. Daniels. Constructed in 1864, it incorporated six spans to cross the Wabash River and further serve the National Road.

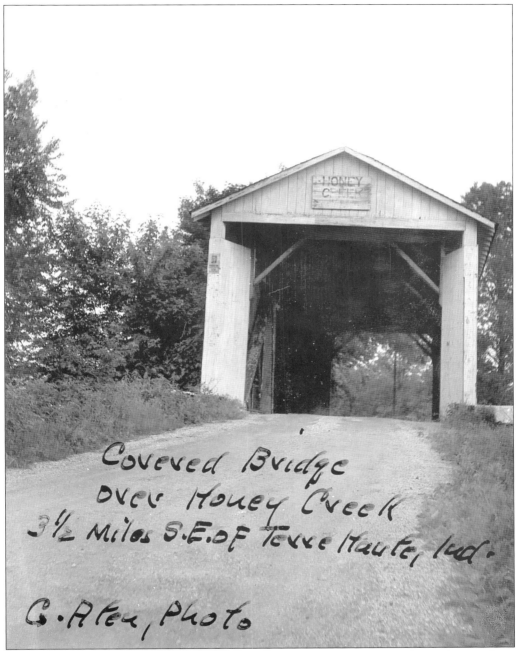

VIGO COUNTY. Honey Creek Bridge in Vigo County was, at one point, located some three and a half miles southeast of Terre Haute. Originally it crossed Honey Creek, as shown in this 1940s photograph. Later it was relocated to Fowler Park where it spanned a small lake. This was the only Vigo County covered bridge listed in the official listing of covered bridges released in 1940; the grand Old Wagon Bridge in nearby Terre Haute had disappeared several decades earlier. Photographed by George Aten, it was one of hundreds of bridges photographed and logged into the handwritten journal of the statewide traveler.

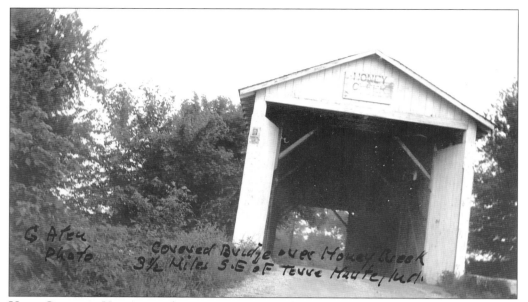

VIGO COUNTY. Here is another vintage view of the Honey Creek covered bridge in Vigo County as it appeared in the 1940s. This structure was located three and one-half miles southeast of Terre Haute and was the only Vigo County covered bridge to be listed in the Directory of Covered Bridges of Indiana in 1940.

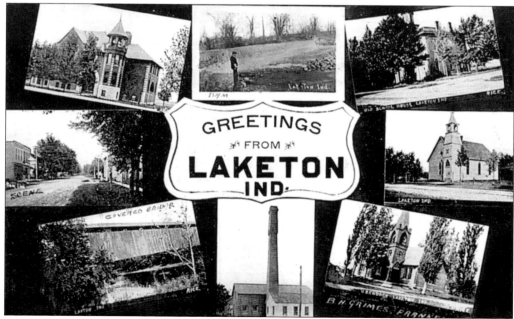

WABASH COUNTY. Laketon covered bridge in Wabash is featured in this greetings postcard from the early 20th century. The Laketon Bridge was at the edge of the community, which had a population of about 500 citizens by 1930. The bridge allowed travelers to cross the Eel River.

WABASH COUNTY. Liberty Mills Bridge in Wabash County across the Eel River is seen here. This is the approach to the covered bridge as it looked in the summer of 1947. It was one of five covered bridges reported by the state as still operational in Wabash County during that decade.

WABASH COUNTY. North Manchester Bridge in Wabash County can be seen here. Located at South Mill and Sycamore Streets, it was constructed in 1872 across the Eel River. This view was photographed by George Aten in August of 1947.

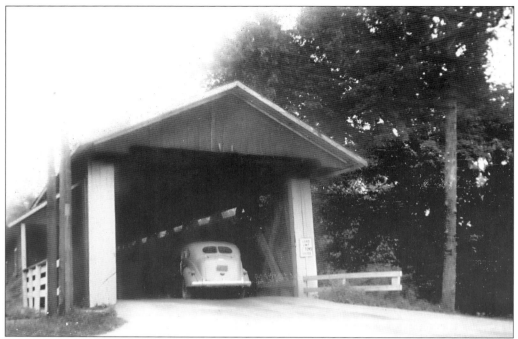

WABASH COUNTY. An automobile sits just inside the covered bridge at North Manchester in Wabash County. One of the few covered bridges in the state with an attached sidewalk on the outside, both the structure and the sidewalk were a product of the Smith Bridge Company, which incorporated a double intersectional system of timbers.

WABASH COUNTY. Above is a postcard view of the North Manchester covered bridge, c. 1948. Inside, the Smith Bridge Company structure was 18 feet across, said to have the widest interior measurement of any covered bridge in Indiana.

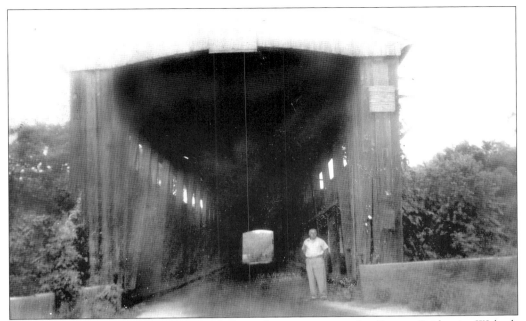

WABASH COUNTY. Here, a figure stands at the entrance to the Roann Bridge in Wabash County during the summer of 1947. The town of Roann had a population of around 430 people at the time the photograph was taken.

WABASH COUNTY. Here is a side view of Roann covered bridge in Wabash County. Constructed in 1877, the Howe truss design bridge extended some 288 feet over the Eel River at the northern edge of the Roann community. Reportedly, it eventually became one of only two covered bridges with a sprinkler system.

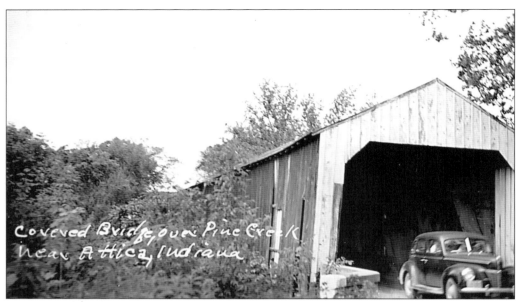

WARREN COUNTY. Pictured above is the covered bridge over Pine Creek near Attica in Warren County. A 1940s automobile emerges from the historic bridge at the Warren County and Fountain County line. In 1949 a national magazine declared: "[T]he covered bridge has seen its day. It is rapidly being replaced by steel and concrete, now cheaper than good timber. The old bridges are not without friends however. A number of historical societies hope to preserve a few of them as historical relics."

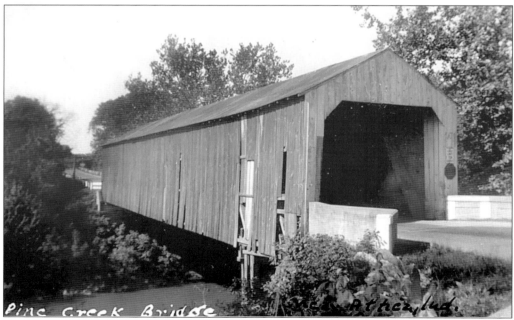

WARREN COUNTY. Pine Creek covered bridge near Attica and the Warren and Fountain county line was photographed in the late 1940s by George Aten.

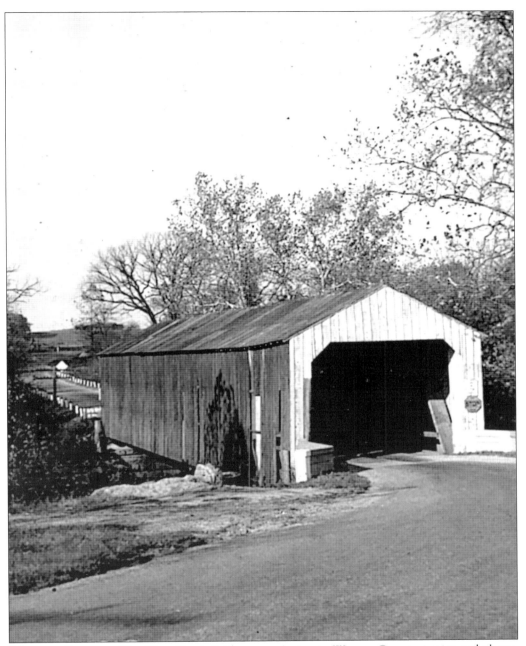

WARREN COUNTY. The Pine Creek Bridge near Attica in Warren County is pictured above. The ends of such bridges which joined the truss structure were fastened together with oak pins sometimes called tree nails. The pins or tree nails were about two inches in diameter and were soaked or even boiled in oil in order to expand their life of service. As iron became available, rods were substituted for some of the wooden members that held tension, and metal bolts were used in place of the earlier wooden tree nails. This transition 'bridged' the time from strictly wooden bridges during the last quarter of the 19th century to the steel structured bridges of the early 20th century.

DIRECTORY OF
COVERED BRIDGES IN INDIANA

REVISED TO DECEMBER 1, 1940

COMPILED FOR
COMMITTEE OF INDIANA HISTORICAL SOCIETY
ON
COVERED TIMBER BRIDGES
BY
ROBERT B. YULE AND RICHARD C. SMITH

Reprinted from
INDIANA HISTORY BULLETIN
VOLUME 18, NUMBER 2, FEBRUARY, 1941
INDIANAPOLIS

INDIANA DIRECTORY. This is a cover of the Directory of Covered Bridges of Indiana, as revised in December 1940. The study and listing by Robert B. Yule and Richard C. Smith was compiled for the Committee of the Indiana Historical Society on Covered Timber Bridges. The directory document hundreds of 'still standing' covered bridges in the Hoosier state. Much of the material was drawn from county road maps printed in 1937 by the Indiana Highway Survey Commission. Data was also provided by the State-Wide Highway Planning Survey conducted by the United States Department of Agriculture in the late 1930s.

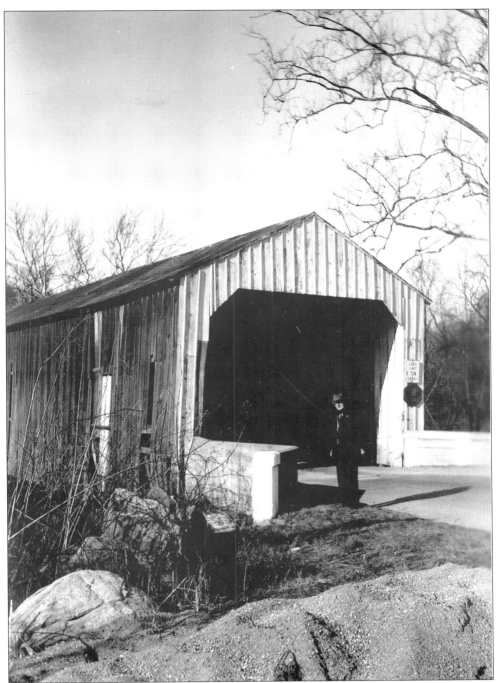

WARREN COUNTY. Independence Bridge at Williamsport in Warren County is pictured above. This was the only Warren County covered bridge included in the Directory of Covered Bridges of Indiana of the 1930s and early 1940s. This black and white photograph of the entrance of the historic bridge was taken during the late 1940s. At the time, the town of Williamsport boasted a population of slightly over 1,000 persons.

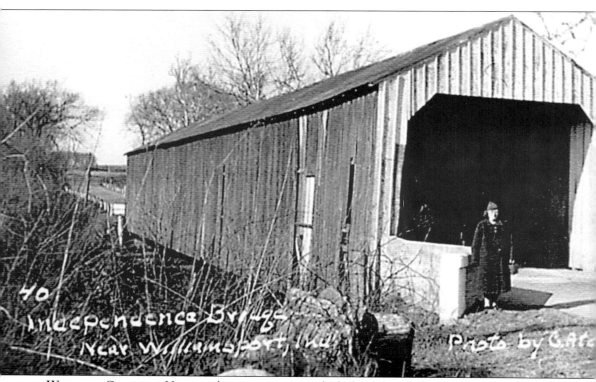

WARREN COUNTY. Here, a lone woman stands before the Independence Bridge near Williamsport in Warren County. The photo was taken by George Aten in the late 1940s. Aten observed that bridges of this type usually used oak plank decks, which were set to allow for settlement under heavy loads. Often the bridges were tested by driving a herd of cattle over them. "In their dark interiors," wrote Aten, "the animals huddled together and, as they moved along provided both a concentrated load and a high degree of vibration."

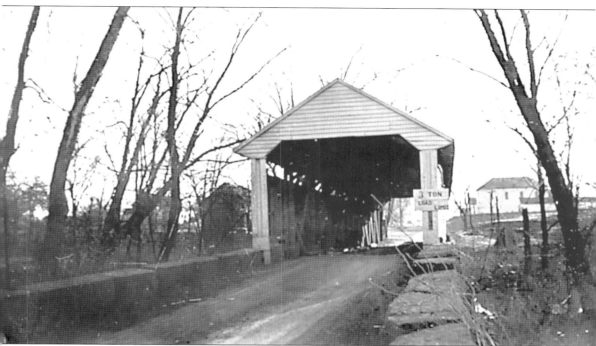

WARRICK COUNTY. This covered bridge at Millersburg in Warrick County took travelers across Pigeon Creek. This black and white photograph of the bridge and roadway was taken in March of 1938. At the time, the photographer noted that the structure had been built in Warrick County in 1874, and added, "[W]e have the rack at our store with the contractors and the team names on it." Other records indicate two other covered bridges in the county, including the Coles Creek Bridge over Coles Creek and the Tennyson Bridge also over Coles Creek.

WARRICK COUNTY. Millersburg Bridge over Pigeon Creek in Warrick County is pictured here as seen during the 1940s. Photographer George Aten described this view as the "near west" aspect of the bridge. Aten observed that, "when bidding for a job those covered bridge builders often brought models of their bridges to demonstrate their skill. Town halls would be thronged with local citizenry and out-of-town bridge builders. Some models were elaborately painted and decorated, in order to be strong on eye appeal."

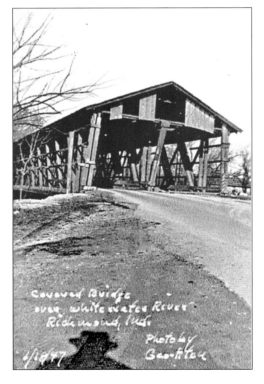

WAYNE COUNTY. The covered bridge over Whitewater River at Richmond in Wayne County is seen here as photographed by George Aten in 1947.

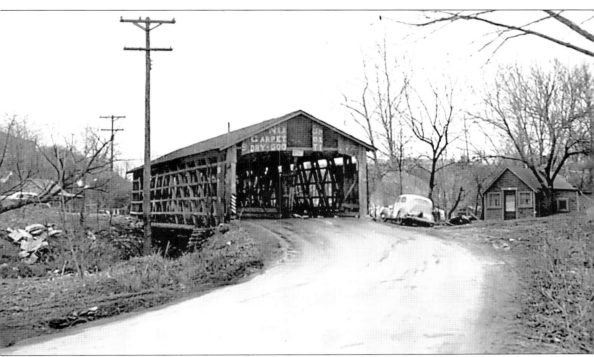

WAYNE COUNTY. Pictured above is the Bridge Street Bridge at Richmond in Wayne County. Carpet and dry goods were advertised on the portal of the bridge, which spanned the east fork of Whitewater River. This photograph was taken around 1938 near the point where Indiana ranked third in the nation in the number of remaining covered bridges. As that decade came to a close, the American Society of Covered Bridges reported that Indiana had 193 covered bridges still standing, just behind Pennsylvania and Ohio. Years later in the 1940s, after losing a number of covered bridges, the group reported Indiana had slipped to fourth in the nation, trailing Oregon, Pennsylvania, and Ohio.

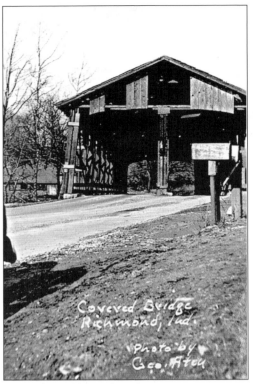

WAYNE COUNTY. The covered bridge at Richmond in Wayne County is seen here. Photographer George Aten described this as the "end vertical view" of the bridge. This is the 9th photograph taken by Aten during the 1940s in a journey that eventually included more than 400 sites and scenes of covered bridges in Indiana.

WELLS COUNTY. The last covered bridge in Wells County as it stood some six and a half miles northwest of Bluffton is seen here. It spanned the Wabash River. The volume *Historic Indiana*, published in 1905, noted Wells County was most progressive regarding roadways. "Wells County built 102 miles of gravel roads last year, while another county built but one." The above bridge was the only Wells County structure included in the 1940 Directory of Covered Bridges of Indiana.

Two

Covered Bridge Celebrations

As far back as the early 1930s there was a spirit of pride surrounding the heritage of covered bridges in Indiana. One of the first efforts at preservation was the formation of the Covered Timber Bridge Committee of the Indiana Historical Society in 1930. Chairman of the group was *Indianapolis Star* artist Frederick Polley. A decade later, the national American Society of Covered Bridges acknowledged "those sketches in the *Indianapolis Star* have been one of the major factors in the growing recognition being accorded Indiana's covered bridges throughout the nation."

During the 1930s, there were efforts to move and preserve distinguished covered bridges in Indiana as the 'modern' highway was rebuilt to accommodate an ever-increasing flow of traffic. A no-longer needed covered bridge in Putnam County, for example, was removed to the Brown County State Park in 1932, where it remains a landmark today.

By the 1940s, the state of Indiana's vast number of well-designed and well-constructed covered bridges was attracting attention from all parts of the United States. In early 1946, a national magazine noted that Indiana's Parke County had more "covered timber bridges" in a single county than practically any other spot in the nation. And they were not just any old structures but "some of the nation's finest examples of Burr truss construction in America."

Not surprisingly, the people of Parke County realized the tourist potential of the splendor of dozens of magnificent covered bridges within their county's boundaries and got organized. The Parke County Covered Bridge Festival was first formed in 1957 and was hailed by the American Society of Covered Bridges as having met with "phenomenal success in promoting covered bridges as tourist attractions."

Today, the state of Indiana is a leader in the celebration of covered bridges. There are covered bridge festivals in Rockville and surrounding areas in Parke County (including Billie Creek Village); in Moscow in Rush County; Roann in Wabash County; Spencerville in DeKalb County; Matthews in Grant County; and in Westport in Decatur County. Special events are also held in Nashville in Brown County and in Metamora in Franklin County. (See page 127 for more details.)

GREETINGS FROM INDIANA. This mid-20th century postcard promotes the many covered bridges in Indiana as a tourist attraction for both Hoosiers and the rest of the nation.

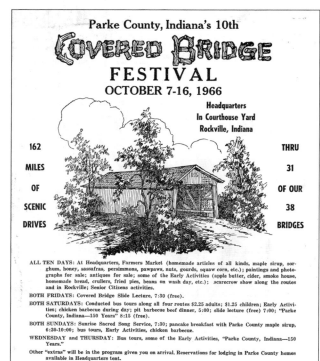

PARKE COUNTY. Here is the program from Parke County, Indiana's 10th Covered Bridge Festival, held in October of 1966. At the farmers market in Rockville, tourists could treat themselves to everything from sorghum and "maple sirup", to persimmons and pawpaws. The main attraction however was the tour through 31 of 38 then-existing bridges. The festival had begun with 39 bridges but lost one, number 3, due to arson in 1960. The 1966 program noted, "during the nine years of Festival history most of these bridges have seen changes. All are in a program of repair and painting; two have been bypassed and two have been moved."

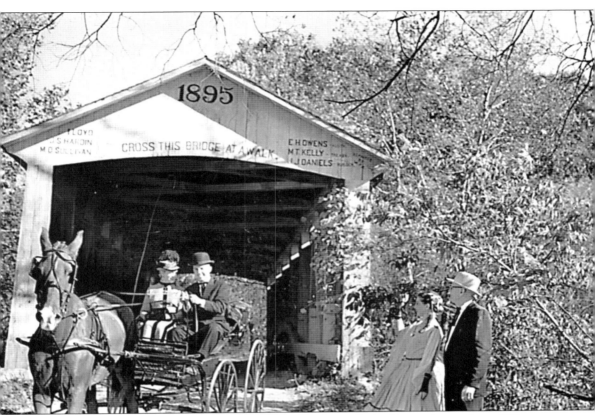

PARKE COUNTY. The famed Billie Creek Covered bridge in Parke County is seen here. Villagers in vintage costume promote the festival and tourism around 1959. This image of the 1895 bridge built by J.J. Daniels over Williams Creek was distributed by the Parke County Covered Bridge Committee, a forerunner of the Parke County Covered Bridge Festival Committee. A program in 1966 noted "the Festival is an annual event so pleasantly different from most civic celebrations that each year it attracts many new guests as well as return visits from previous attenders." Today, the Billie Creek Village and Farmstead help to ensure Parke County's title as covered bridge capital of the world. Billie Creek Village is open during weekends and for special events from Memorial Day weekend through the last weekend in October. A Billie Creek Christmas is celebrated early in December.

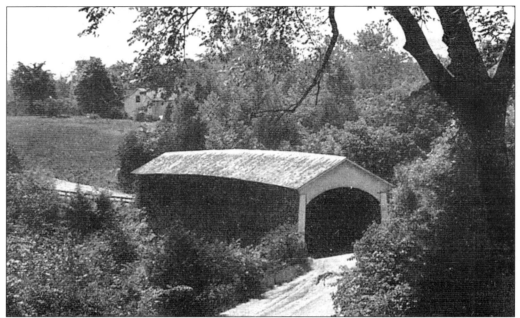

PARKE COUNTY. This is an early postcard view of the covered bridge at Turkey Run State Park near Marshall. It was distributed by Trans World Airlines. The surrounding landscape remains rustic and nearly unchanged from the late 19th century.

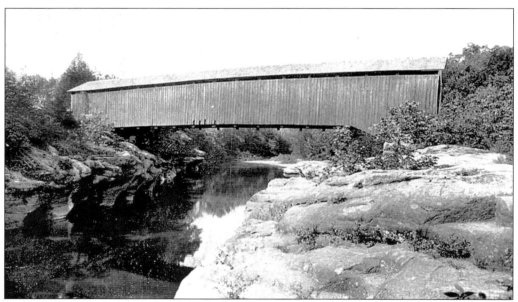

PARKE COUNTY. Seen here is the covered bridge at Turkey Run State Park near Rockville. This postcard view was issued around 1946. Years later, an official of the American Society of Covered Bridges wrote, "any Hoosier worthy of the name should be proud of the folks down in Parke County. Their success in preserving covered bridges, and in bringing local covered bridge tours into the eye of the traveling public is to be highly commended, and is already being emulated in other parts of Indiana."

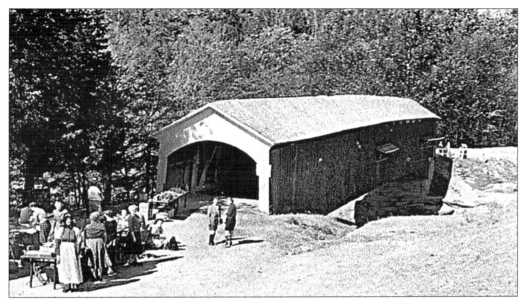

PARKE COUNTY. Costumes and merchandise are featured in this scene of the Narrows Covered Bridge at Turkey Run State Park in Parke County. This image from early 1960s was distributed by the Parke County Covered Bridge Committee. This historic Burr truss bridge was built in the 1880s by Joseph A. Britton. It is part of a major festival celebration in October of each year.

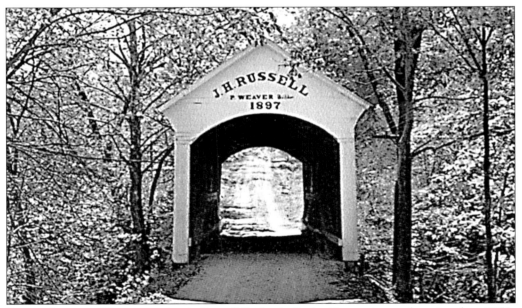

PARKE COUNTY. The one and only Russell Bridge in Parke County is seen here in a late-1950s image which was distributed on behalf of the Parke County Covered Bridge Committee. The Russell, the only privately owned covered bridge of Parke County's vast number, was built in the 1890s across Square Creek Branch. When this photograph was taken, the county still had 39 covered bridges. A fire in 1960 reduced the number to 38. The Parke County Covered Bridge Festival celebration attracts national attention annually every early October.

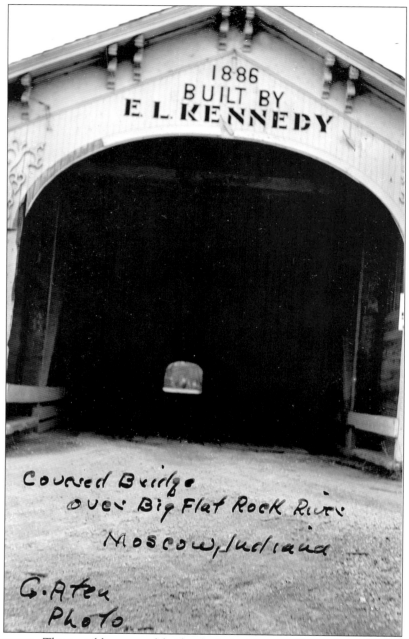

RUSH COUNTY. The notable covered bridge built by Emmett Kennedy at Moscow in Rush County is seen here. Today, this classic covered bridge is part of the Moscow Covered Bridge Festival. The celebration comes to Rush County annually during the last full weekend in June. The bridge was constructed in 1886 over Big Flat Rock River in the long-standing tradition of the Kennedy family. Emmett took over the business from his father, the legendary A.M. Kennedy. For a time, Emmett was joined by his brother Charles in the family bridge-building business. Later, in places like Moscow, Emmett Kennedy carried on the business on his own. This 1940s photograph was taken by George Aten.

Three

INDIANA COVERED BRIDGE FESTIVALS

Cumberland or Matthews Covered Bridge Festival
Grant County
First weekend in September after Labor Day
Contact Roger Richards
Phone 765-998-2928

Moscow Covered Bridge Festival
Rush County
Last full weekend in June
www.moscowfestival.org
Contact Pat Daieb
Phone 317-634-9406

Parke County Covered Bridge Festival
Parke County
Starts second weekend in October
Lasts 10 days
Billie Creek Village
Rockville
Montezuma
Bridgeton
Mansfield
Mecca
www.coveredbridges.com
Contact Billie Creek Village
Phone 765-569-3430

Roann Covered Bridge Festival
Wabash County
First weekend in September after Labor Day
Contact Ann Haupert
Phone 765-833-4871

Spencerville Covered Bridge Festival
DeKalb County
Second weekend in October
www.spencervillecoveredbridgefestival.com
Contact Roberta Carnahan
Phone 260-238-4532

Westport Covered Bridge Festival
Decatur County
First weekend in June
www.coveredbridgeproject.org/events.html
Contact Dave
Phone 812-591-2719

INDEX

Adams Co.	9, 11, 12, 13	Guthrie	60, 61, 62, 63	Putnam Co	85, 86, 87, 88, 89, 90
Allen County	13	Hamilton Co.	45	Randolph Co	91, 92, 93
Attica	112	Harrodsburg	66, 67, 68, 69	Richmond	118, 119, 120
Batson	46	Huntington Co.	46	Rush Co.	93, 94, 95, 96, 97, 98, 99, 126,
Bean Blossom	14	Indianapolis	64		
Brown Co.	14, 15, 16, 17	Jackson Co.	49, 50	Rushville	99, 100
Brownsville	102	Jay Co.	51	Spencer Co.	101
Bryant	51	Jennings Co.	52, 53, 54, 55, 56	Spencerville	31, 32, 33
Butler	30, 31			Union Co.	101, 102, 103, 104, 015
Carroll Co.	18, 19, 20	Knox Co.	56, 57		
Cataract	73	Lake Co.	58	Vermillion Co.	106
Catlin	2	LaPorte Co.	57	Vigo Co.	106, 107, 108
Cayuga	106	Lawrence Co.	60, 61, 62	Wabash Co.	108, 109, 110, 111
Clay Co.	22	Leo	13		
Cloverdale	85, 86, 90	Manhattan	89	Warren Co.	112, 113, 114, 115, 116
Connersville	34	Marion Co.	64, 65		
Crown Point	58, 59	Matthews	39, 40, 41, 42, 43, 44	Warrick Co.	117, 118
Darlington	70			Wayne Co.	118, 119, 120
Decatur Co.	23	Millersburg	117, 118	Wells	120
DeKalb Co.	26, 27, 28, 29, 30, 31, 32, 33	Monroe Co.	66, 67, 68, 69	West College Corner	103
		Montgomery Co	70, 71	Westport	24
Delphi	21	Moscow	96, 126		
Delaware Co.	25	Nashville	14, 15, 16, 17		
Dunlapsville	103, 104	New Salem	97		
Farmland	91	North Manchester	109, 110		
Fayette Co.	34	Owen Co	72, 73, 74		
Fountain Co	34, 36, 37	Parke Co.	2, 75, 76, 77, 78, 79, 80, 81, 82, 83, 84, 122, 123, 124, 125		
Franklin Co.	38				
Ft. Harrison	65				
Grant Co.	39, 40, 41, 42, 43, 44	Pine Lake	57		
		Pleasant Mills	9, 11, 12, 13,		